101
USES
FOR A

MAINE
COON
CAT

Down East Books

Published by Down East Books
An imprint of Globe Pequot
Trade Division of The Rowman & Littlefield Publishing Group, Inc.
4501 Forbes Boulevard, Suite 200, Lanham, Maryland 20706
www.rowman.com

Unit A, Whitacre Mews, 26-34 Stannary Street, London SE11 4AB, United Kingdom

Distributed by NATIONAL BOOK NETWORK

Design by Lynda Chilton, Chilton Creative

Photographs: Lynn Karlin, cover, pgs.6, 128; Grey Geezer, p.126; Takashi Hoshoshima, p.120; Sage Ross, p.116; Hillary Steinau, p.108; Liza Gardner Walsh, p.26; Dreamstime, pgs. 4-9, 12-18, 20, 26-29, 32-34, 39-43, 46-47, 51-56, 60, 64, 68-72, 78-79, 82, 89-90, 92-93, 96-97, 102, 103, 105-107, 110-113, 121, 127; Shutterstock, pgs. 3, 11, 30, 35, 37, 44-45, 50, 58-59, 61, 66, 75, 77, 83, 87, 90, 94, 99, 100, 101, 109, 116-117, 122-123, 132-133; 136; Thinkstock, pgs. 22-23, 36, 48-49, 62-63, 65, 67, 73, 85, 91, 95, 129.

British Library Cataloguing in Publication Information Available

Library of Congress Cataloging-in-Publication Data Available

ISBN 978-1-60893-605-2 (cloth : alk. paper)
ISBN 978-1-60893-606-9 (electronic)

♾™ The paper used in this publication meets the minimum requirements of American National Standard for Information Sciences—Permanence of Paper for Printed Library Materials, ANSI/NISO Z39.48-1992.

Printed in the United States of America

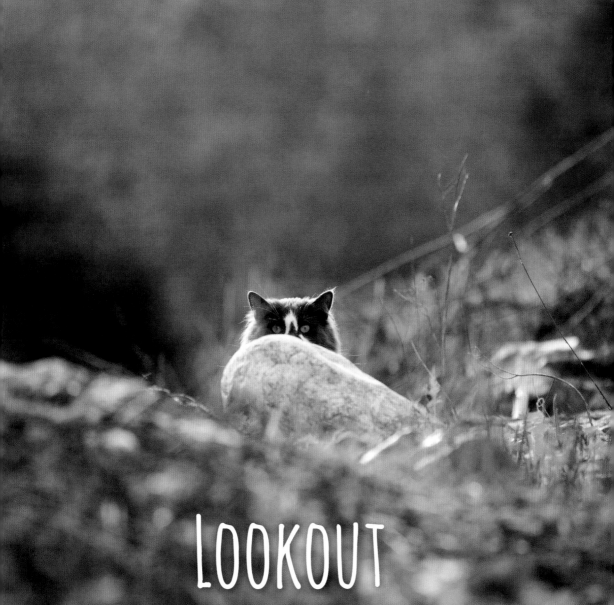

LOOKOUT

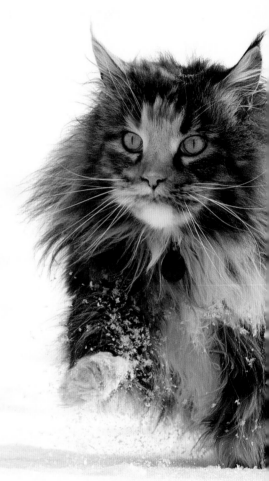

ABOMINABLE
SNOW CAT

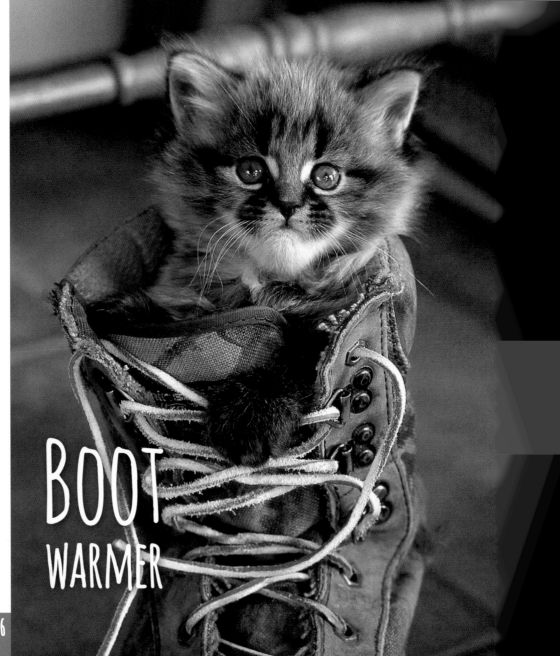

BOOT
WARMER

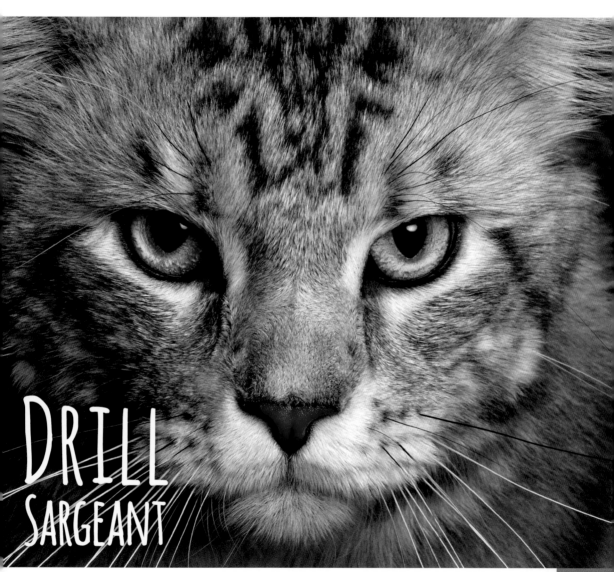

Drill
Sargeant

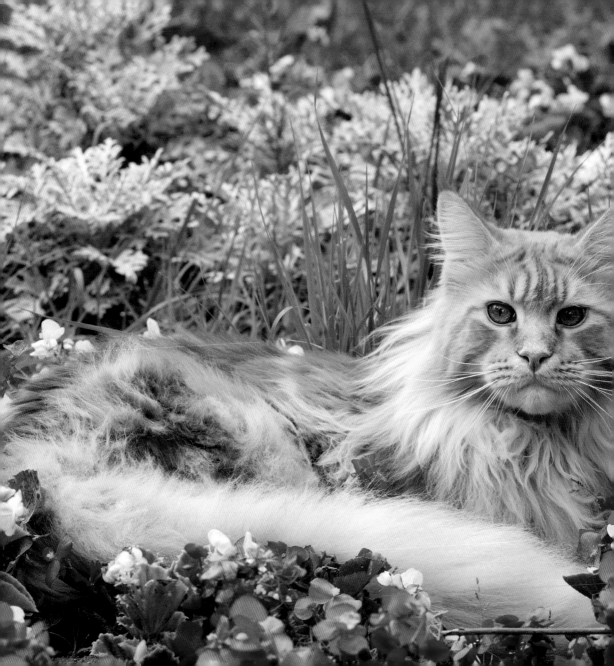

GARDENER

Piano
Tuner

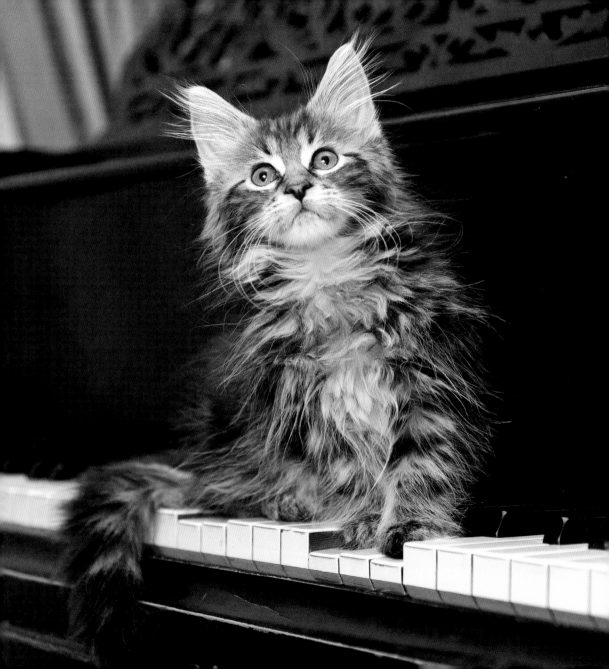

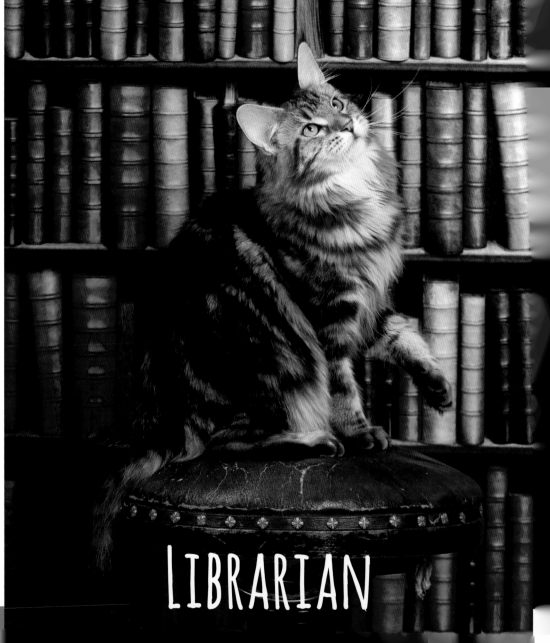

LIBRARIAN

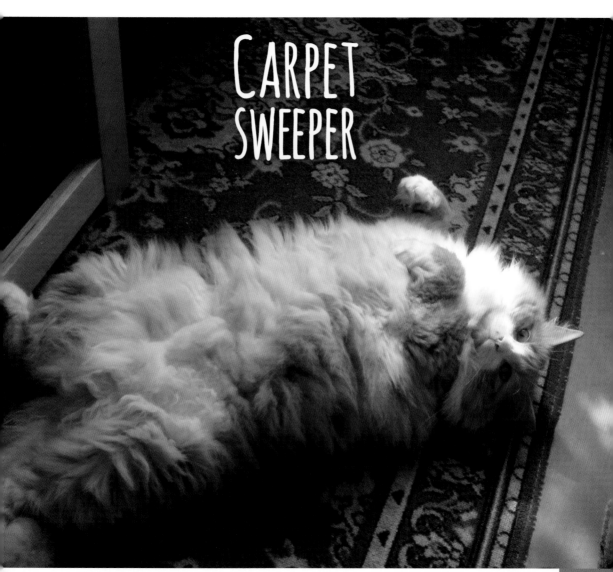

CARPET
SWEEPER

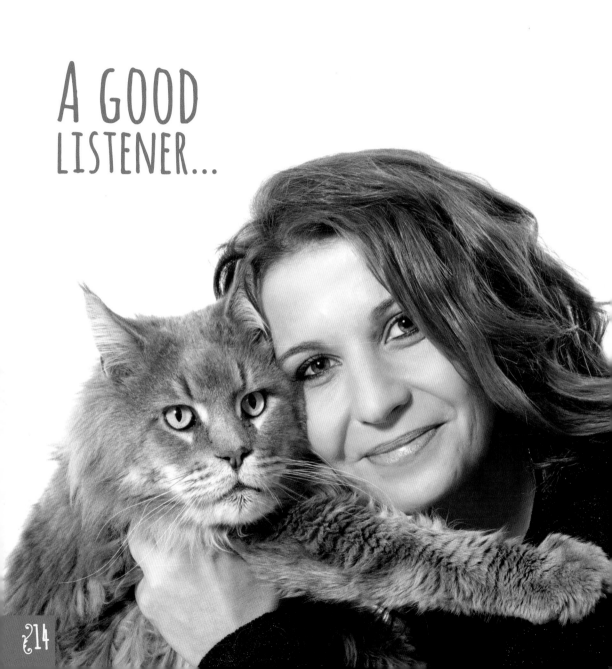

A GOOD
LISTENER...

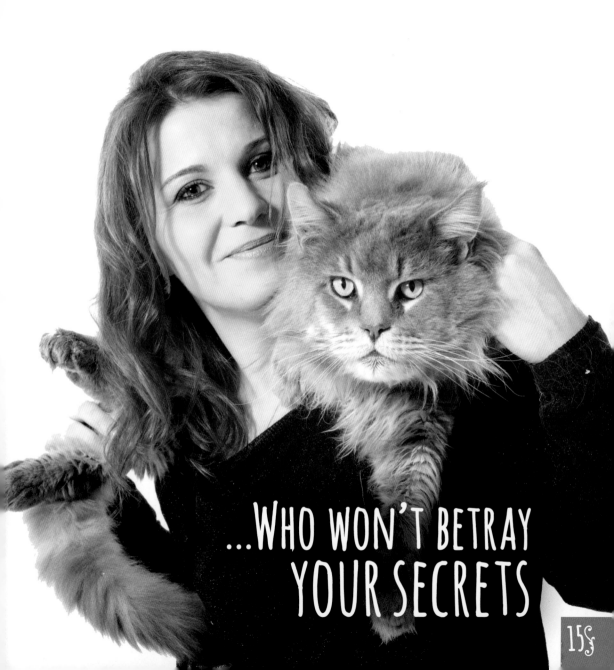

...WHO WON'T BETRAY YOUR SECRETS

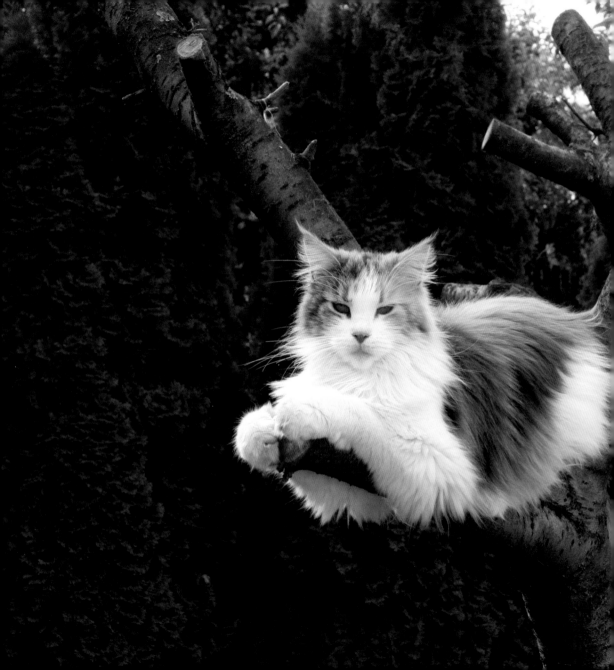

ARBORIST

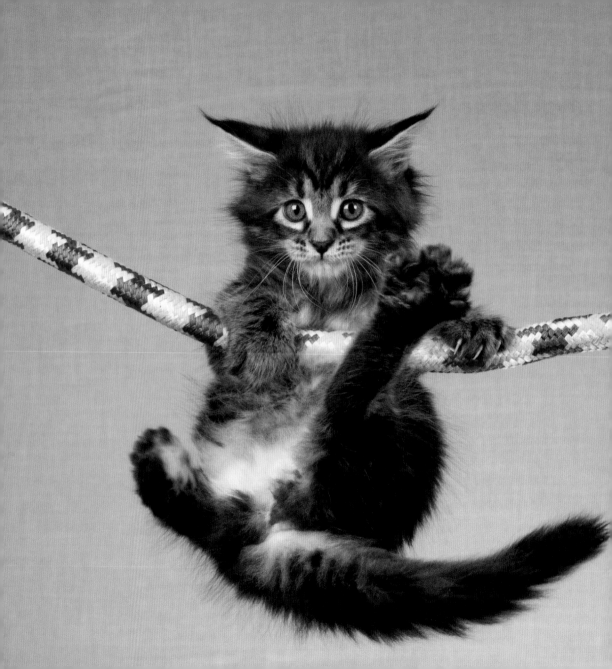

Tightrope WALKER

TAPE
MEASURE

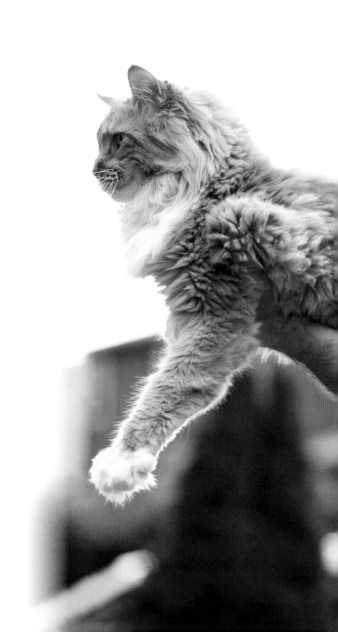

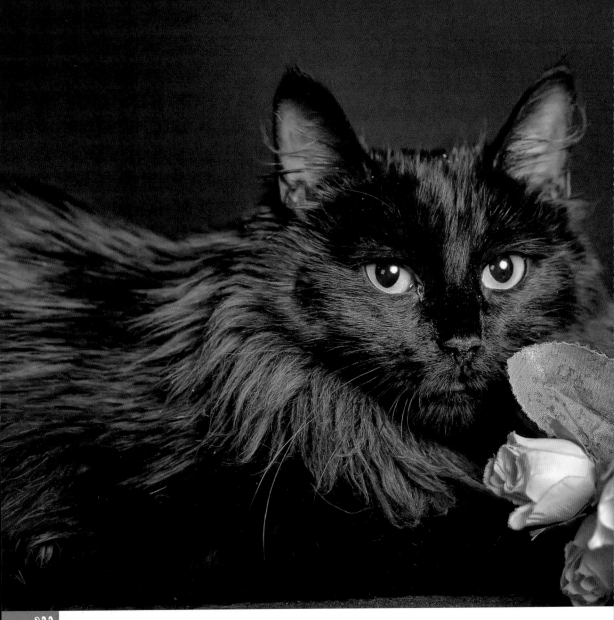

FLORIST

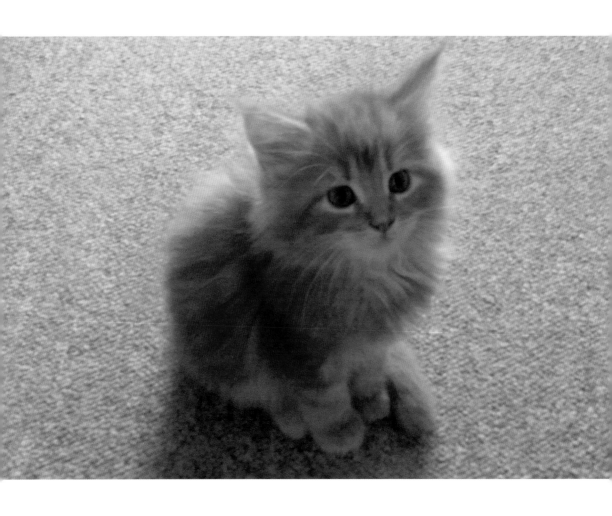

TRIBBLE

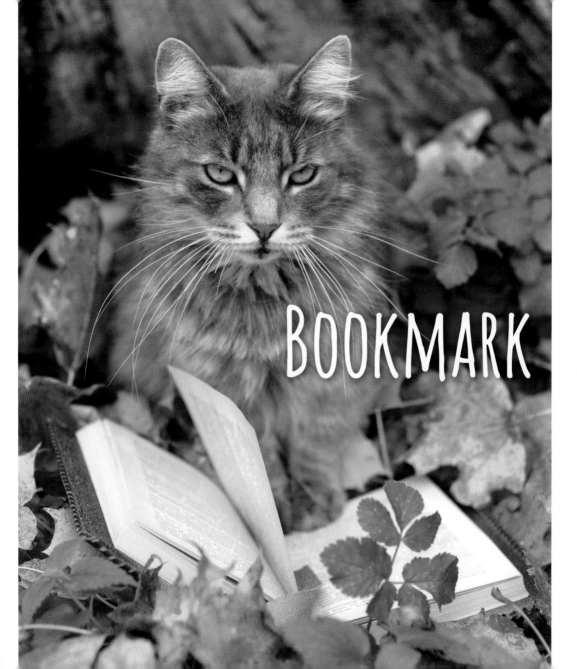

BOOKMARK

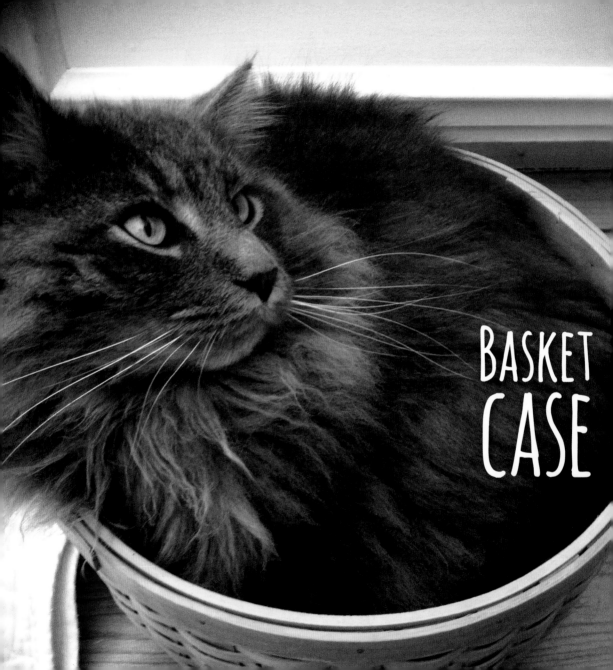

BASKET CASE

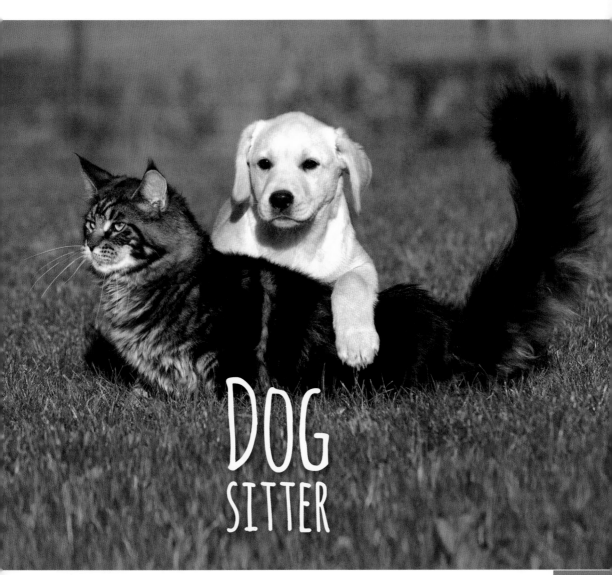

DOG
SITTER

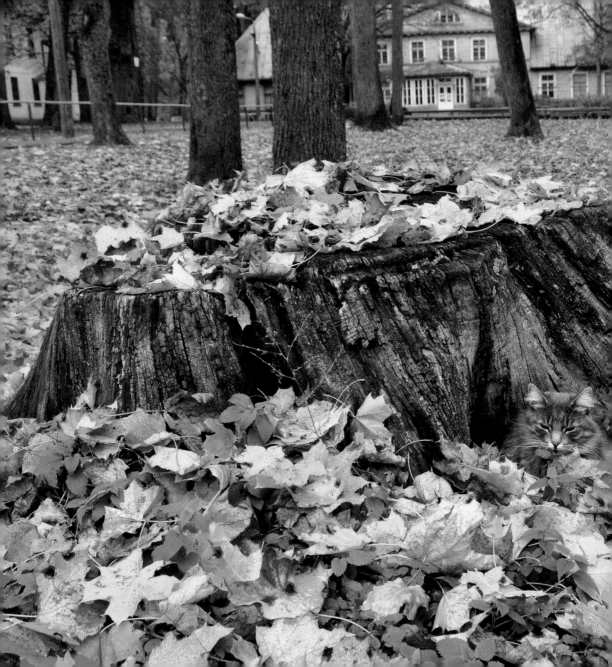

Camouflage

Stocking Stuffers

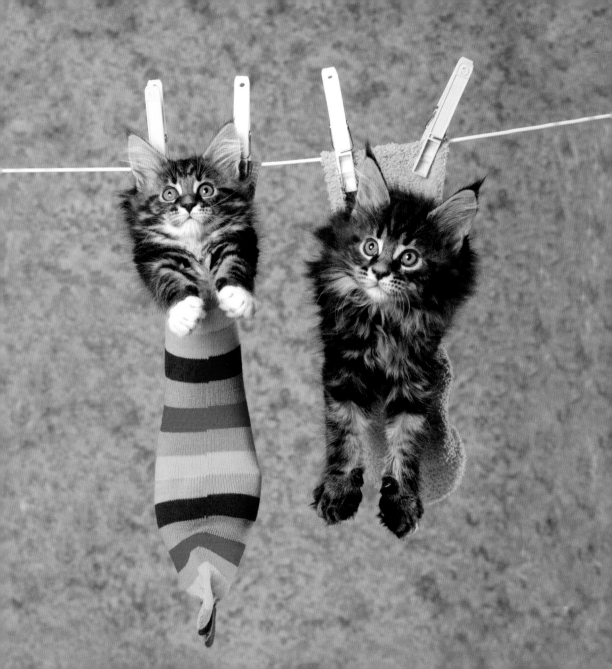

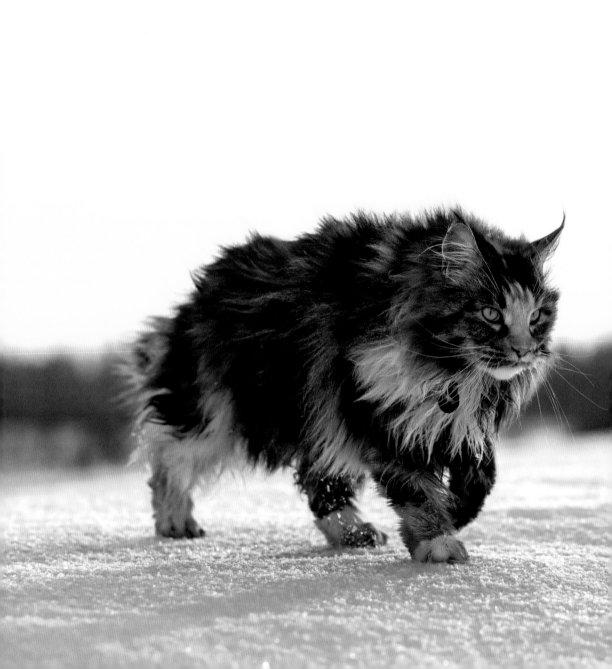

POLAR EXPLORER

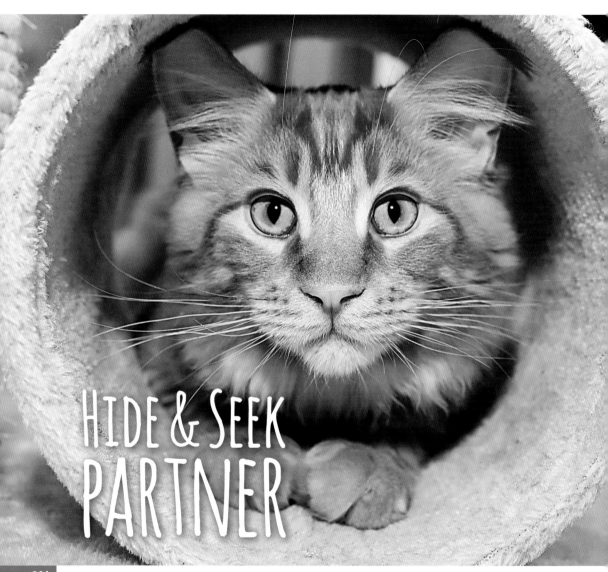

HIDE & SEEK
PARTNER

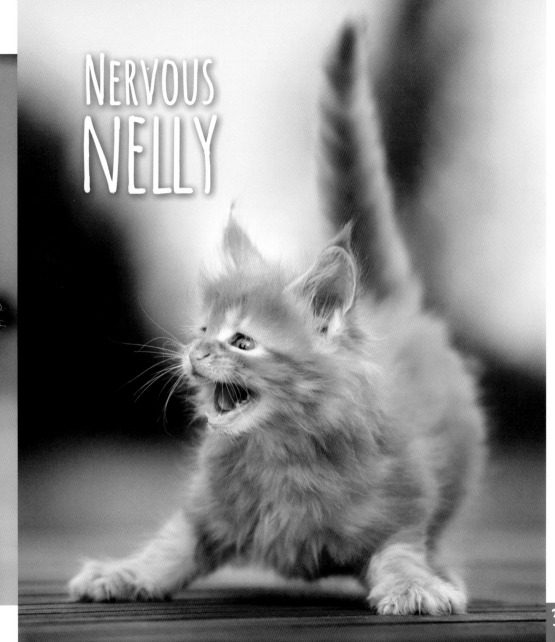

NERVOUS
NELLY

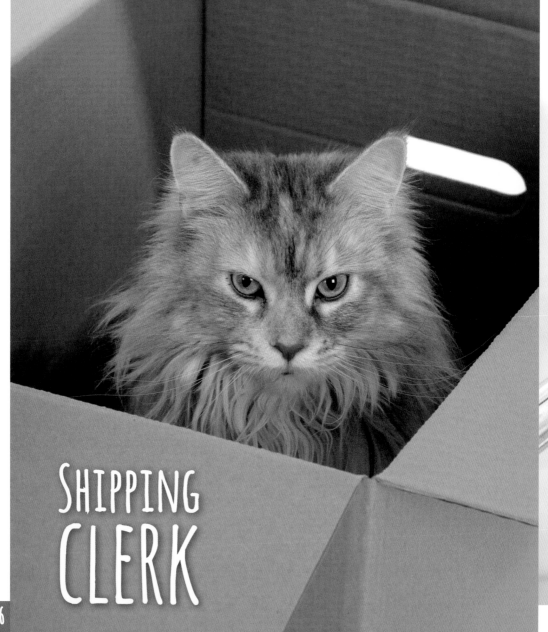

Shipping
CLERK

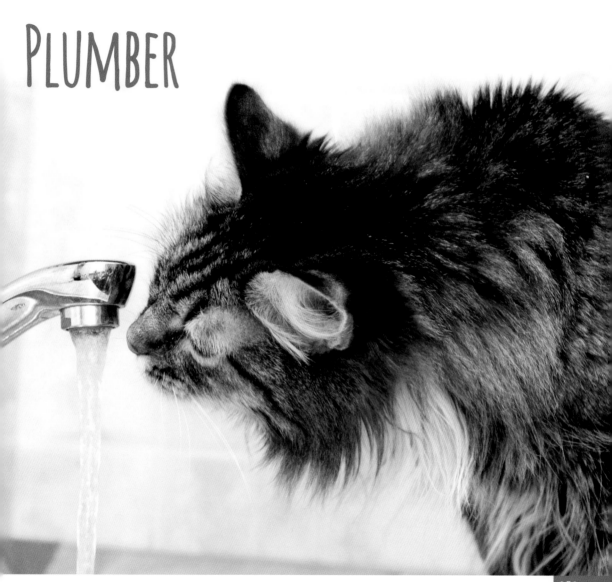

PLUMBER

MONA LISA

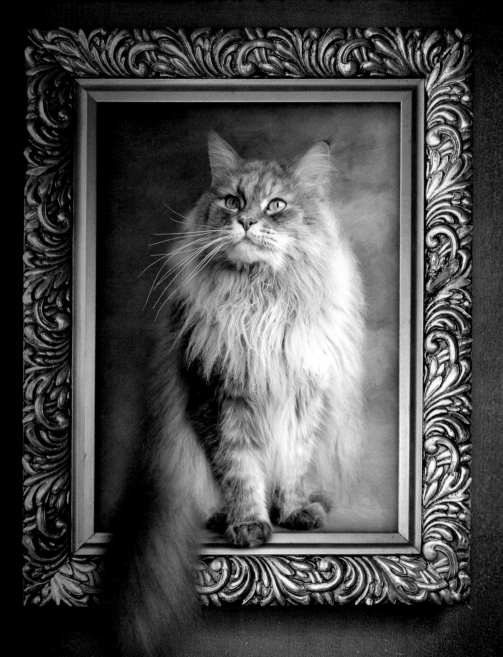

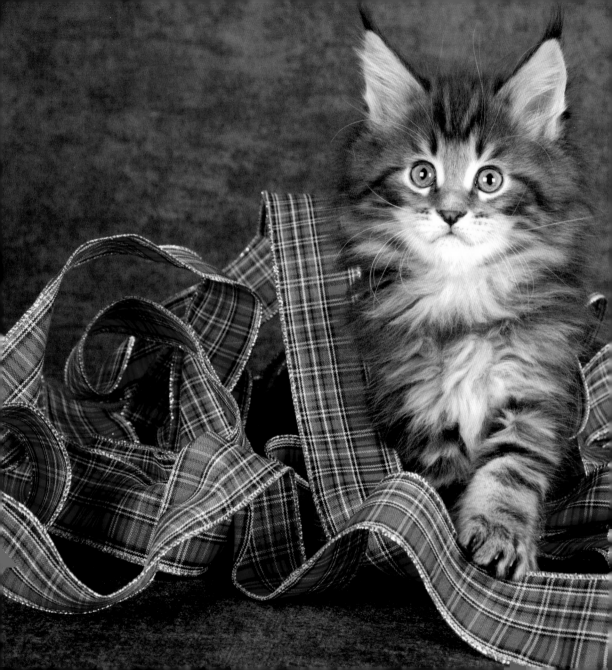

Santa's Helper

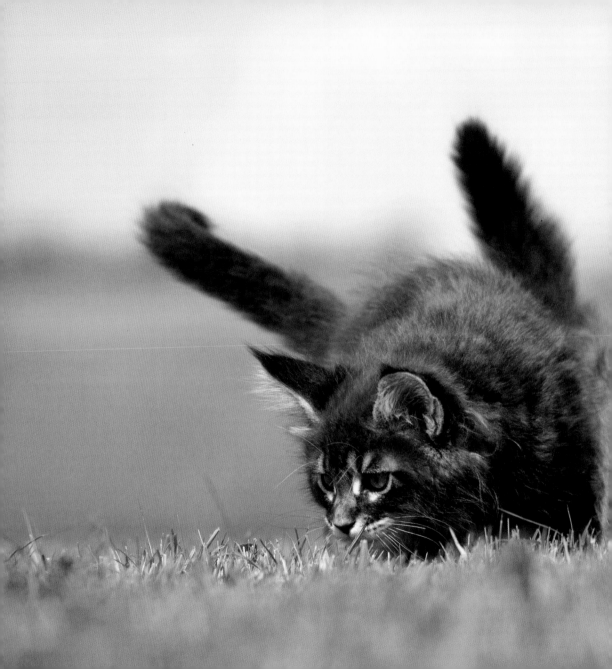

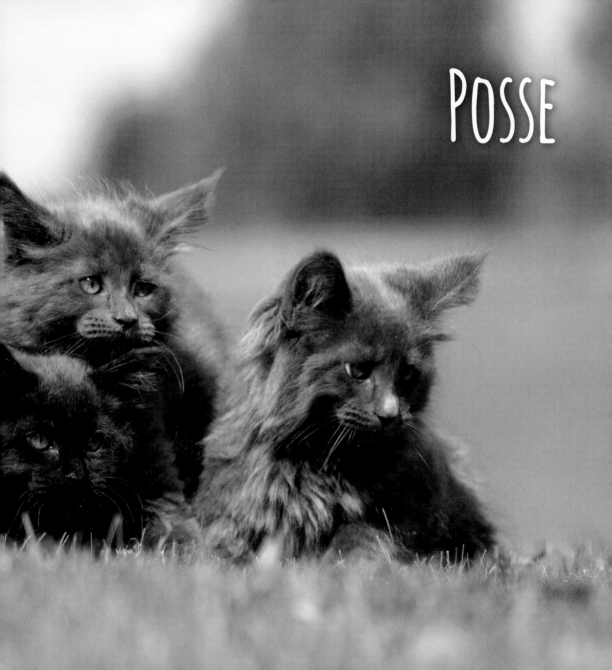

POSSE

Sleeping
BEAUTY

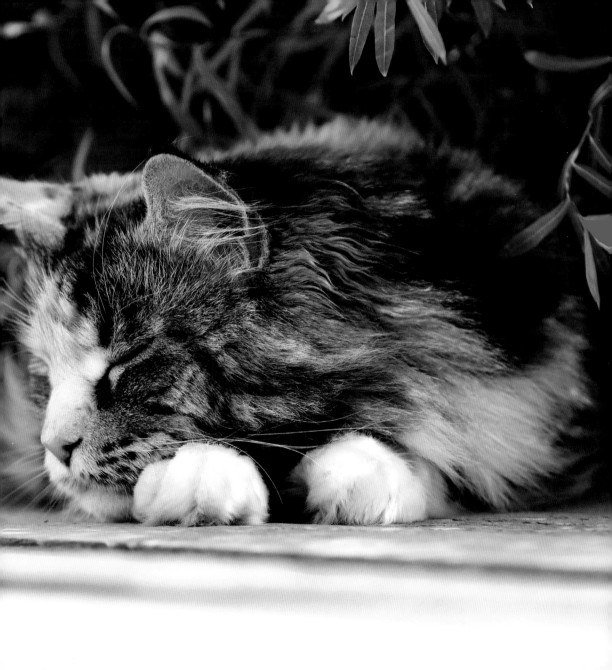

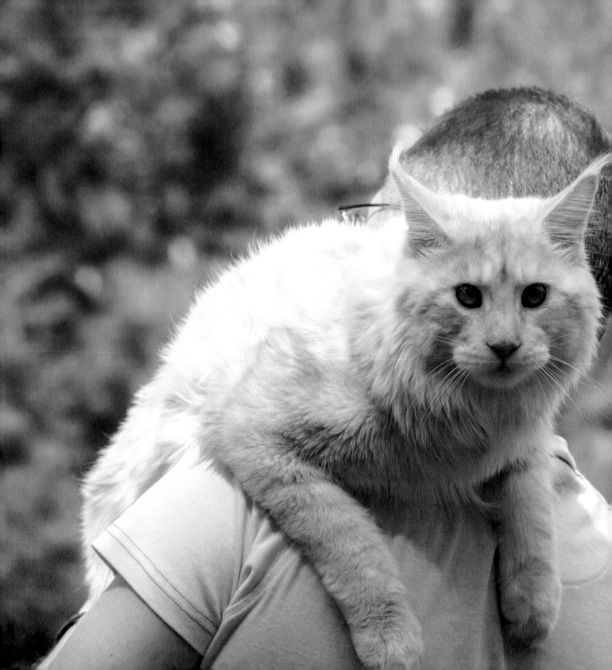

Constant
Companion

TOWEL BOY

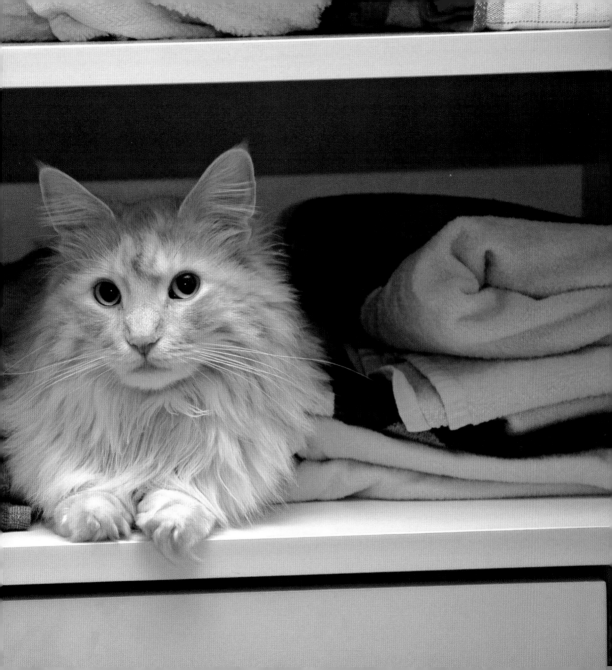

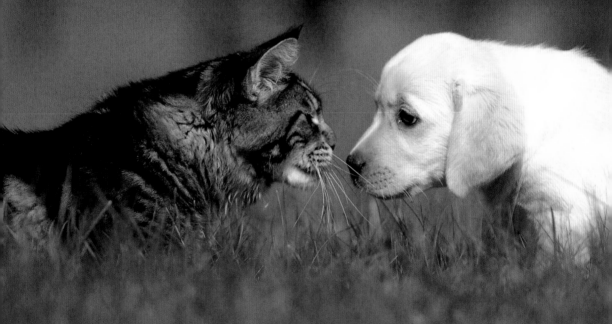

TOUGH
NEGOTIATOR

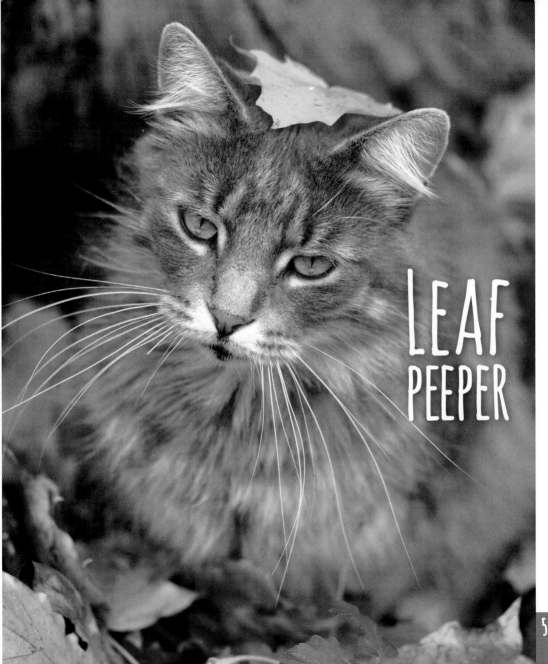

LEAF
PEEPER

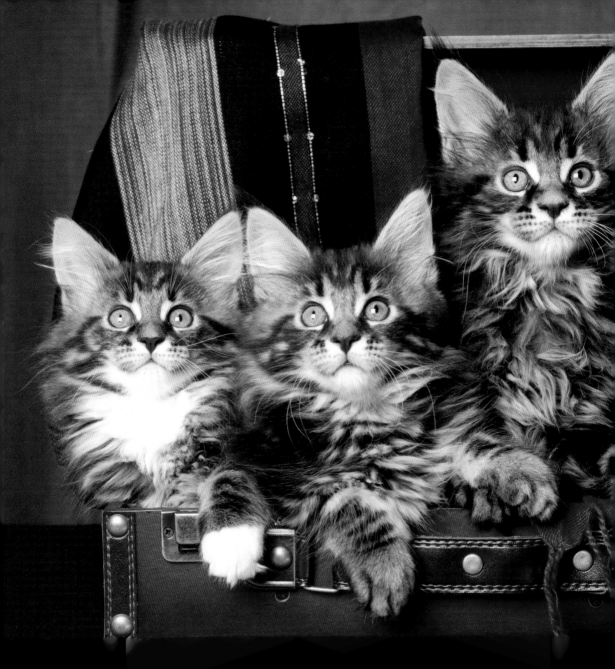

Sassmaster

STAND-UP COMIC

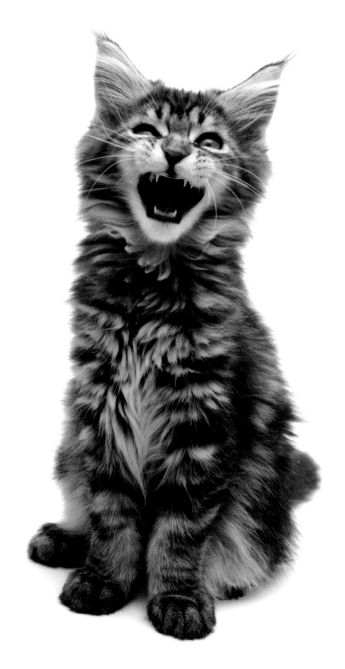

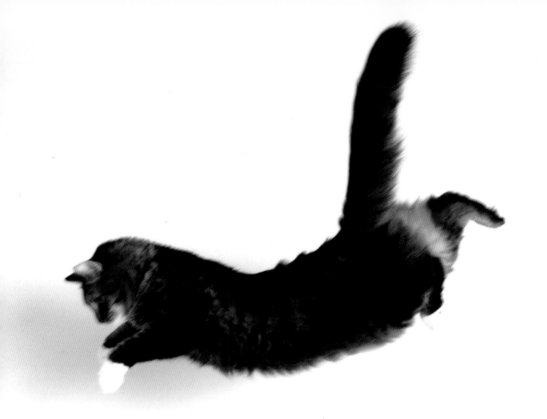

Supercat

59

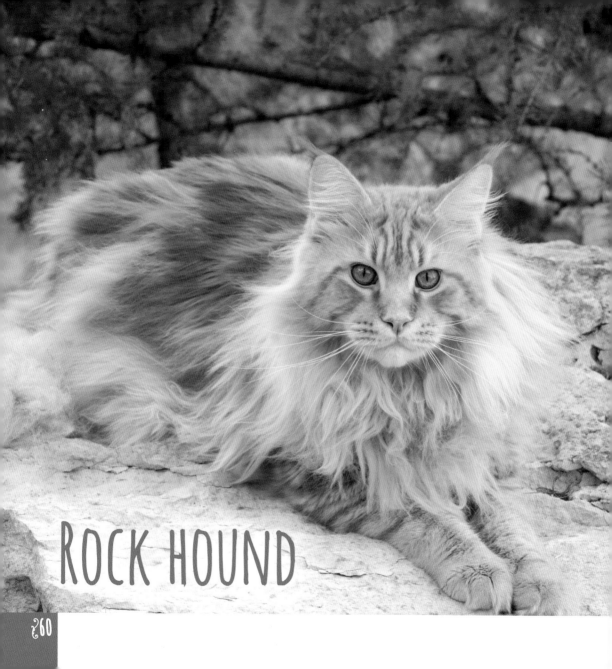

ROCK HOUND

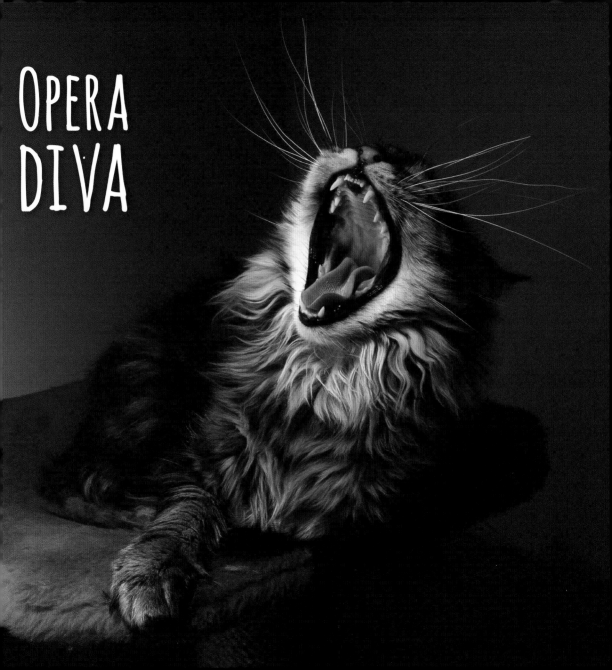

BED
WARMER

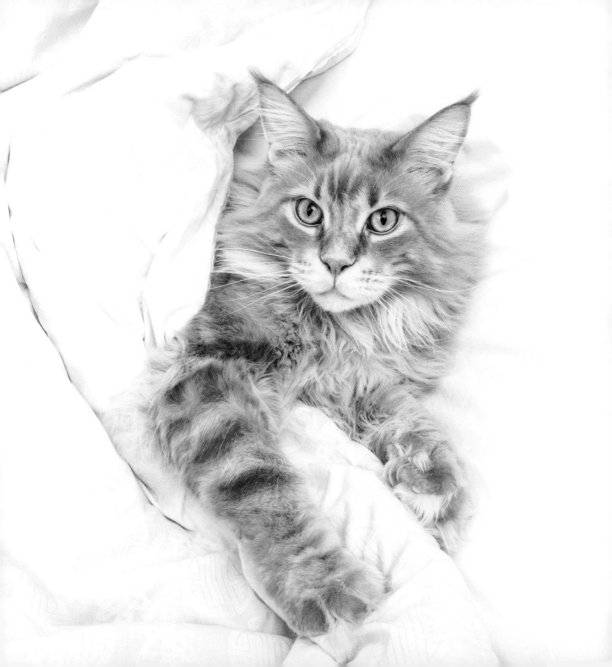

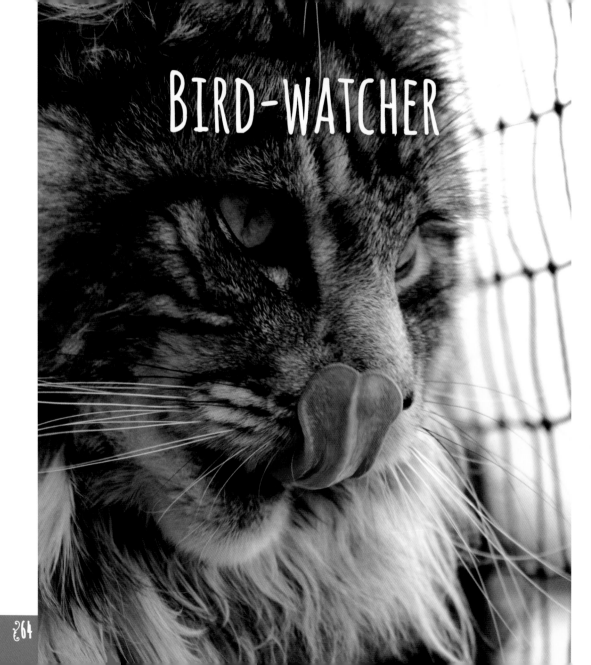

BIRD-WATCHER

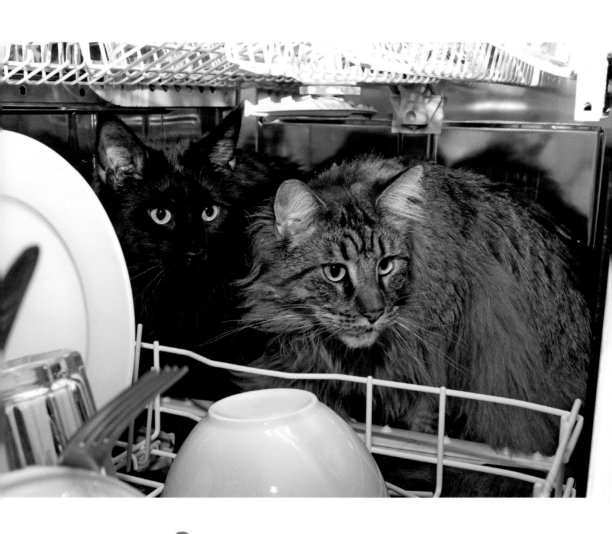

DISHWASHER

65⫰

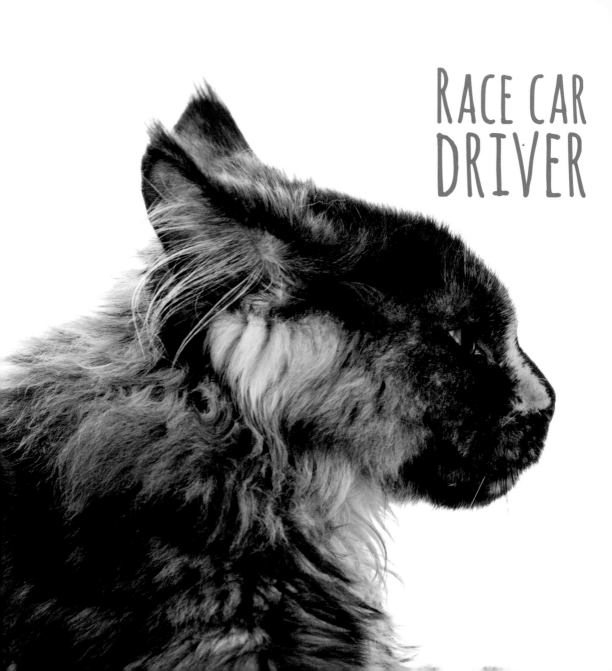

RACE CAR
DRIVER

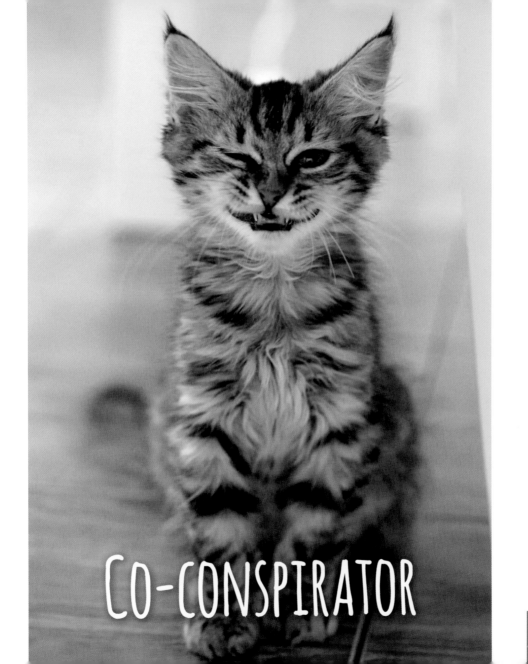

CO-CONSPIRATOR

67

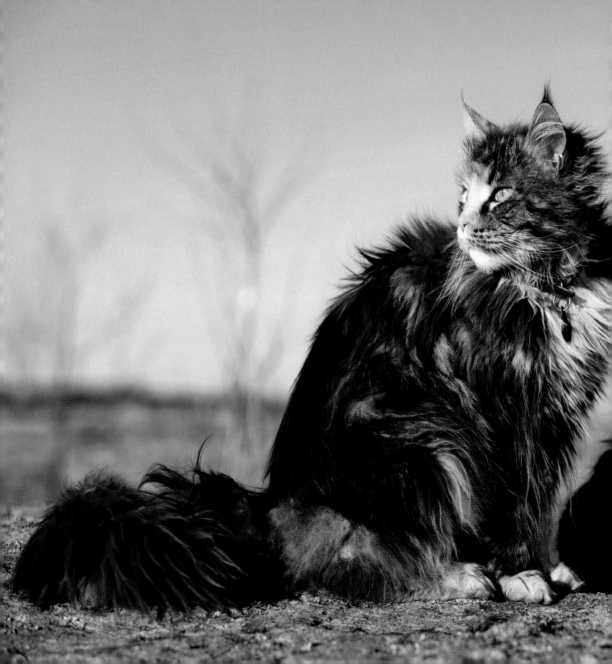

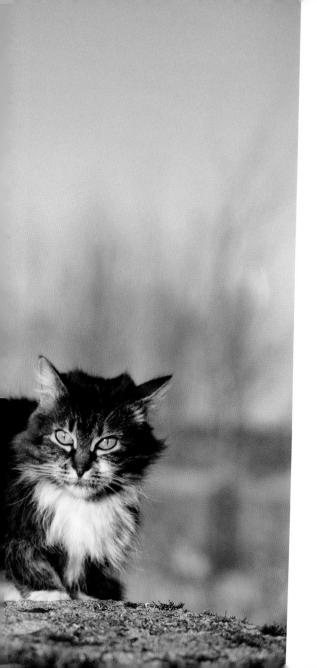

BUTCH AND SUNDANCE

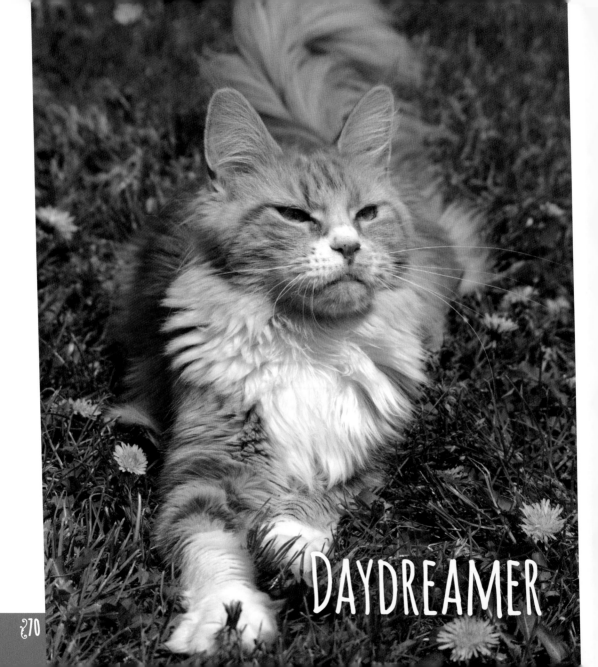

DAYDREAMER

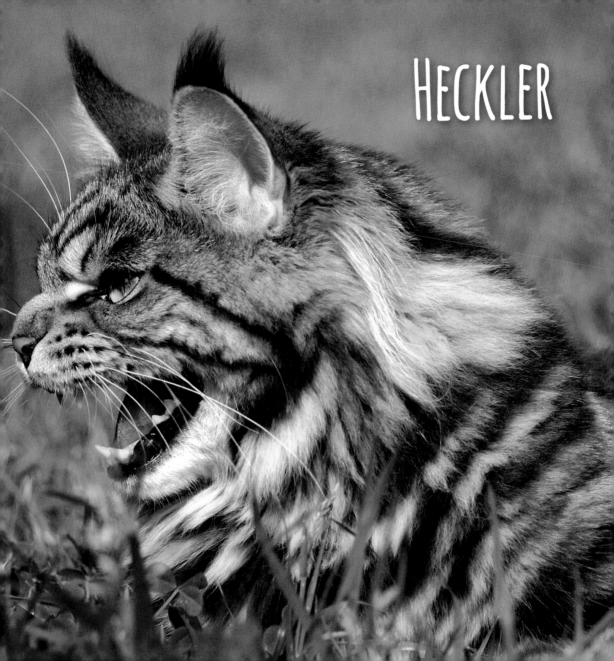

HECKLER

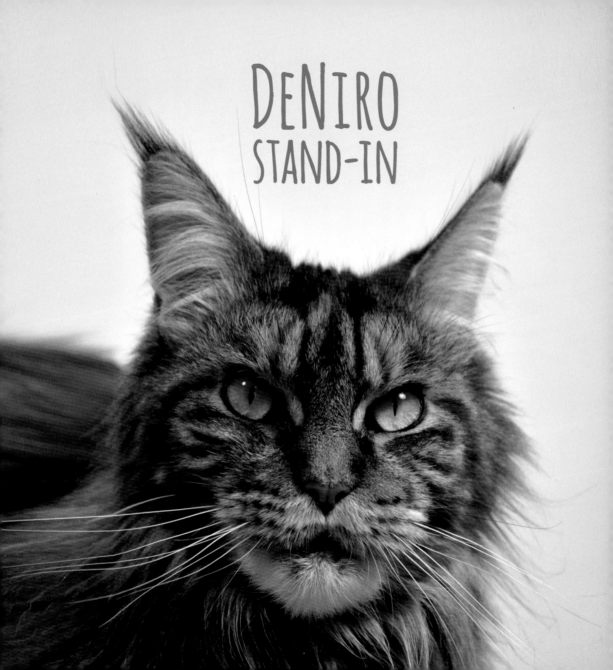

DeNiro
STAND-IN

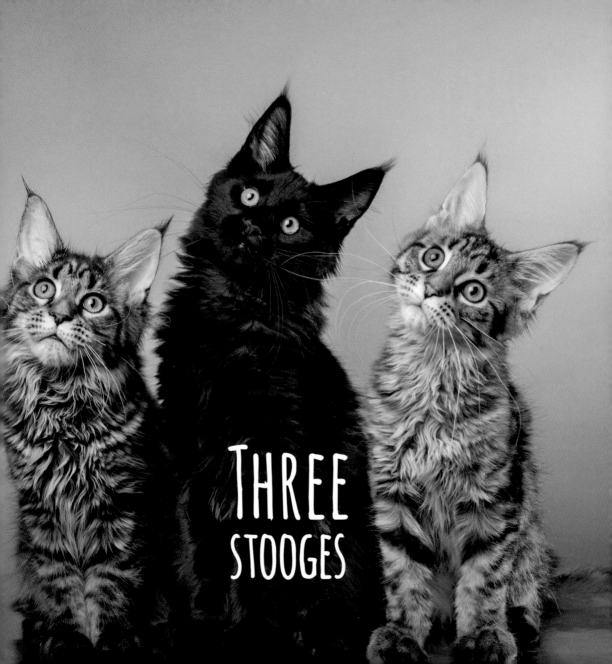

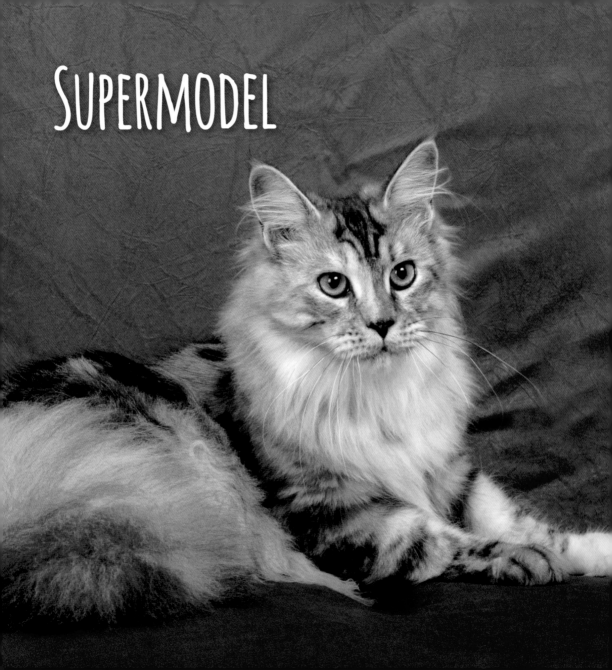

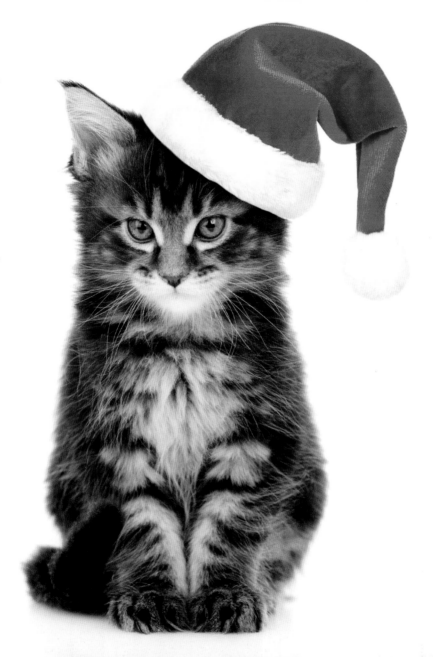

ELF
ON A
SHELF

75§

YOGA
INSTRUCTOR

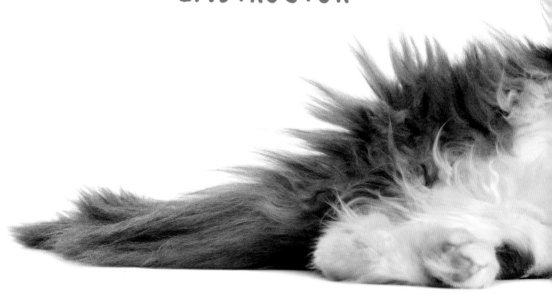

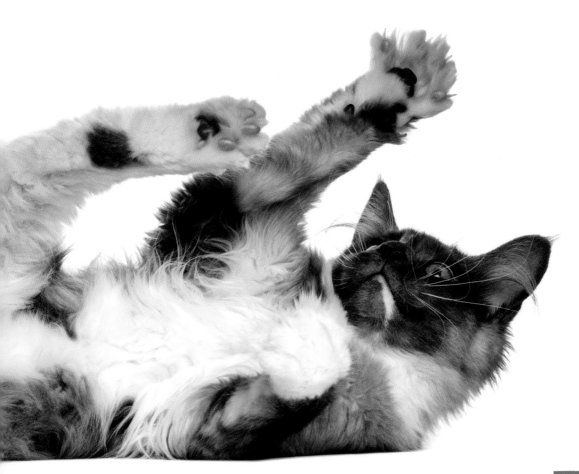

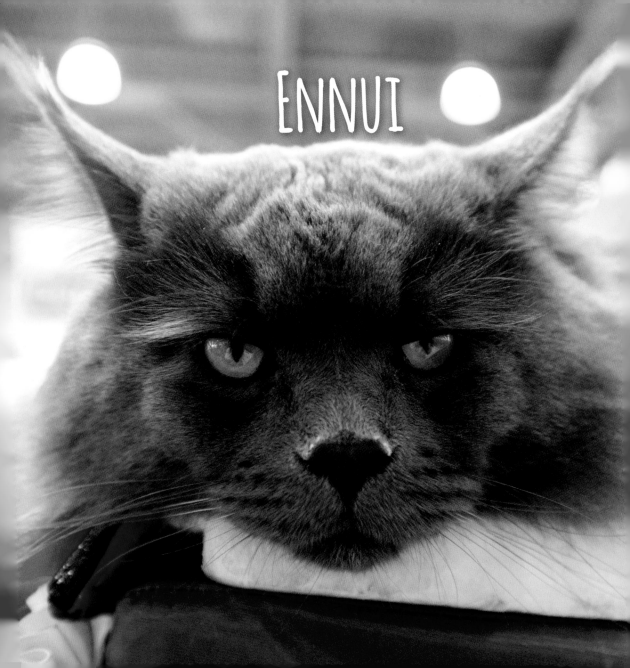

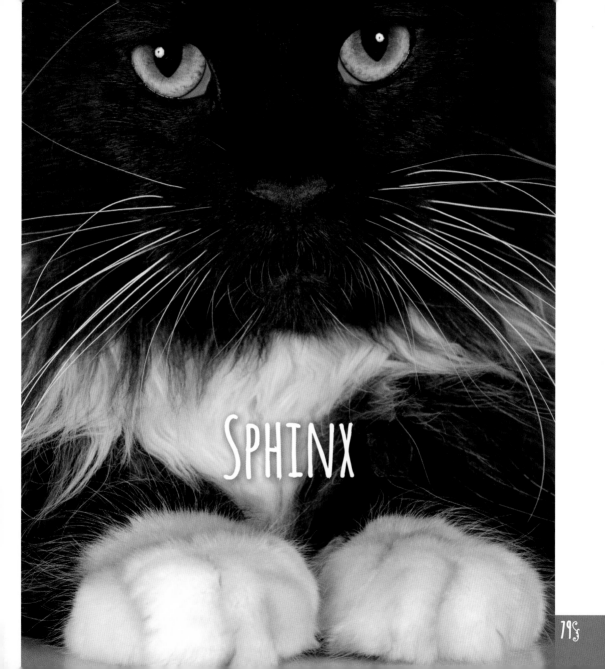

SPHINX

FERN

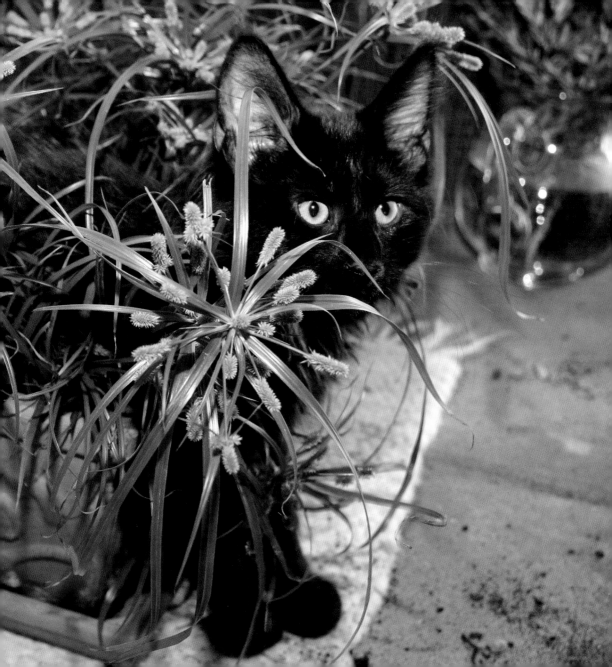

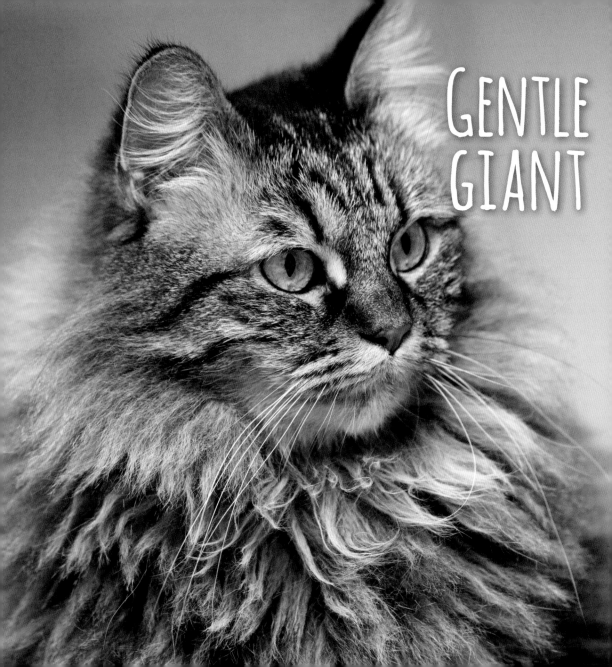

GENTLE
GIANT

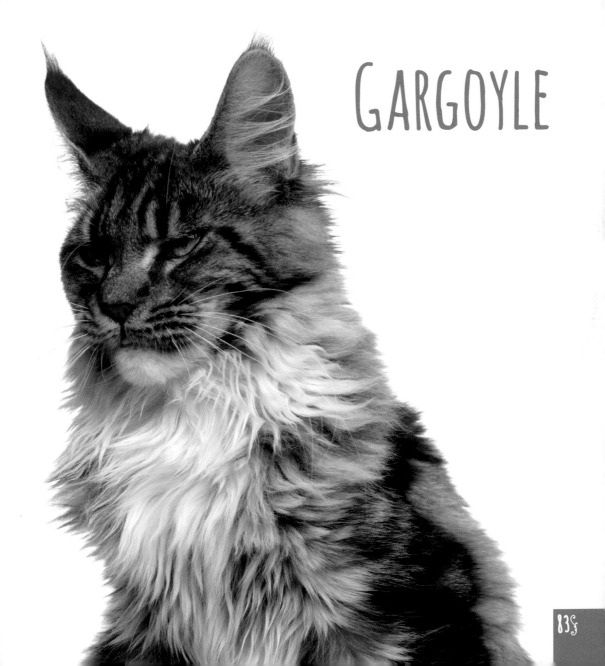

GARGOYLE

83♂

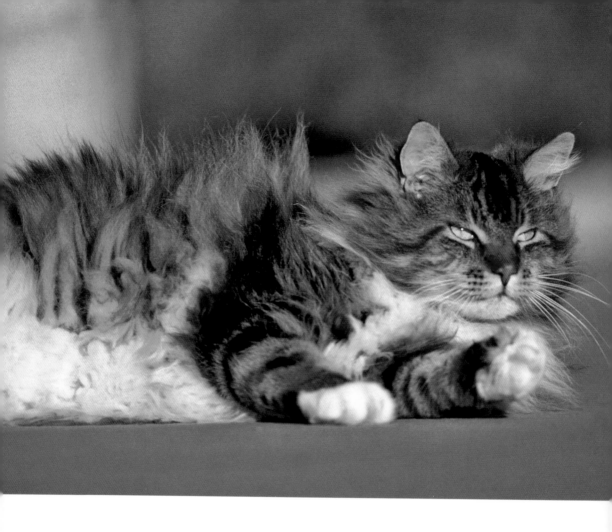

SUNBATHER

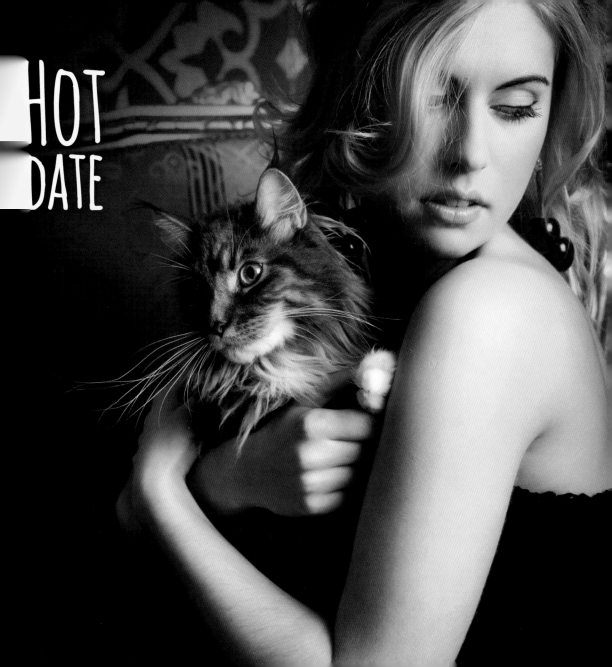

HOT
DATE

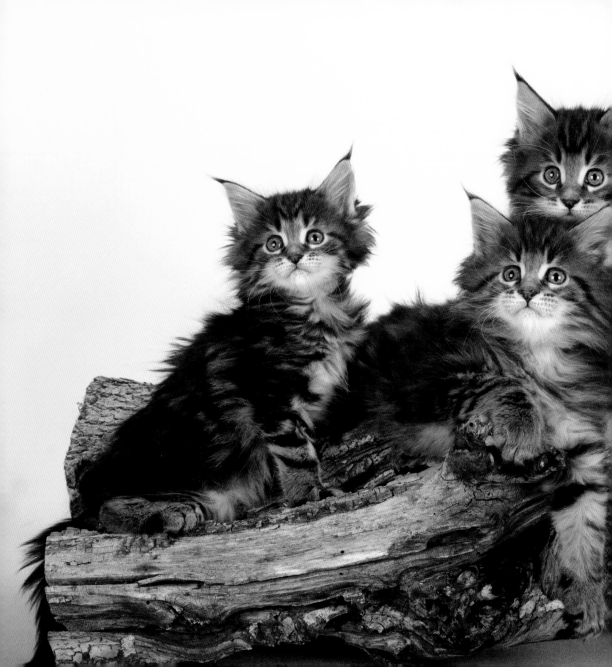

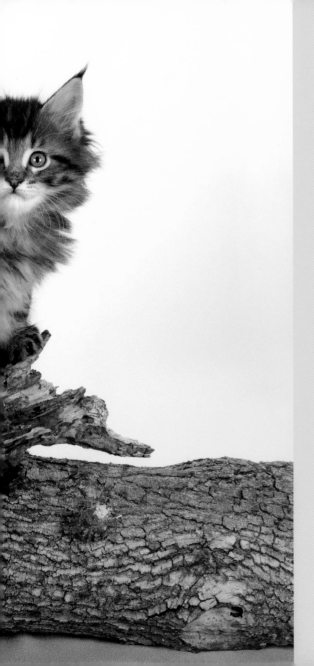

LOG
JAM

87

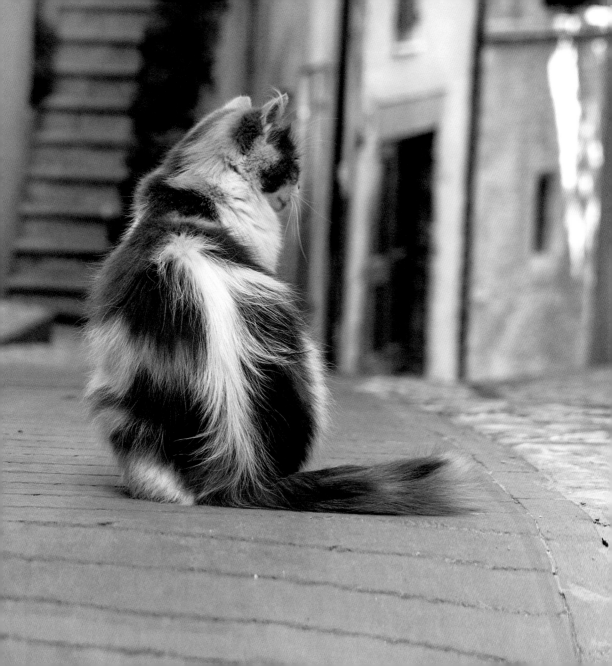

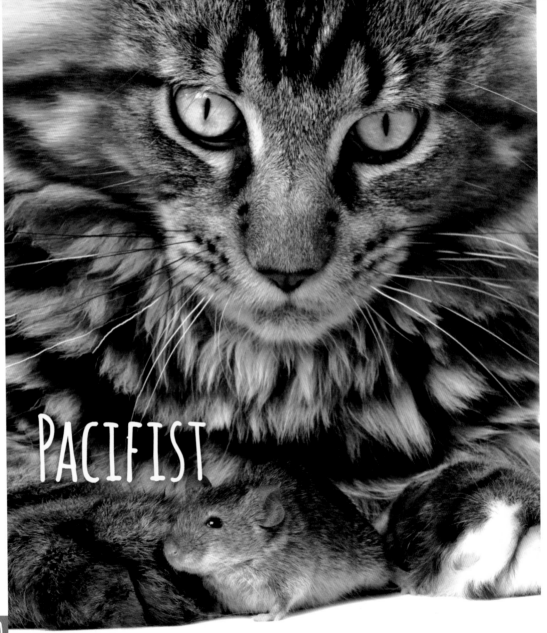

PACIFIST

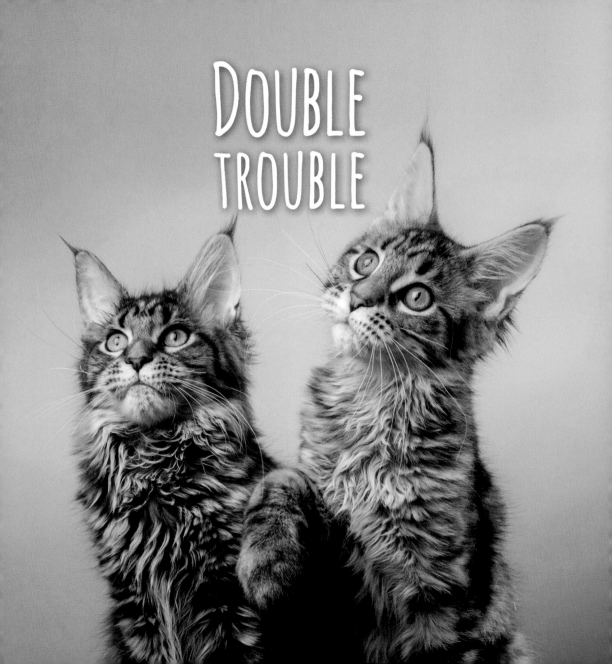

Nature
Guide

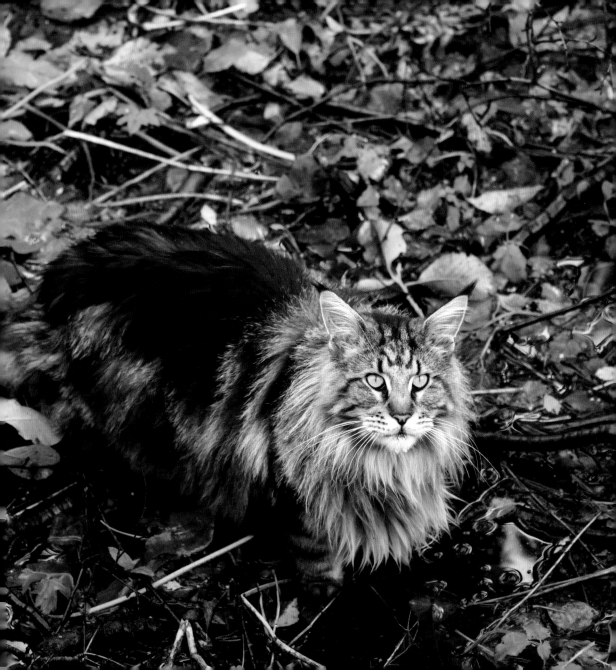

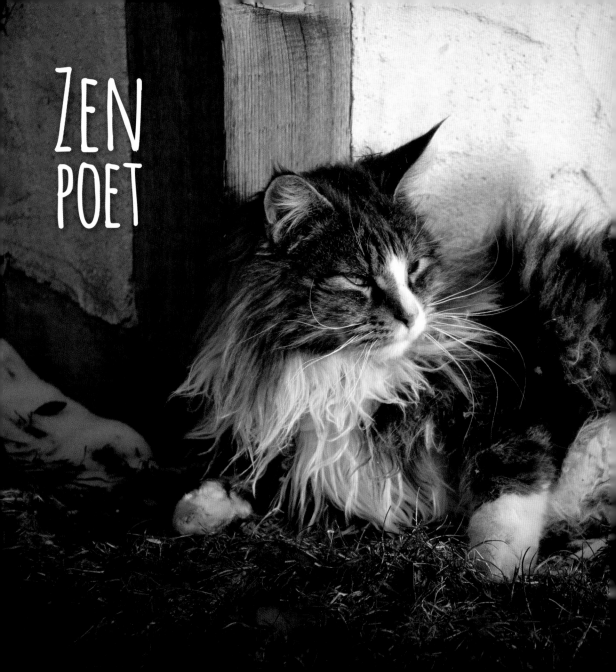

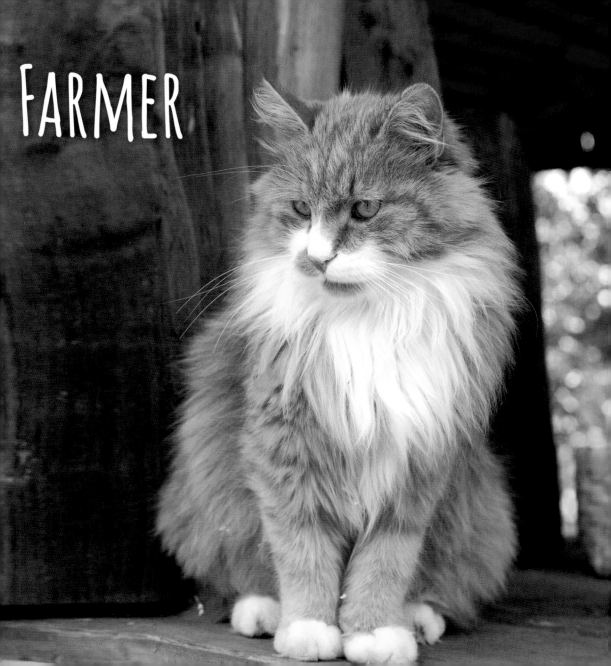

FARMER

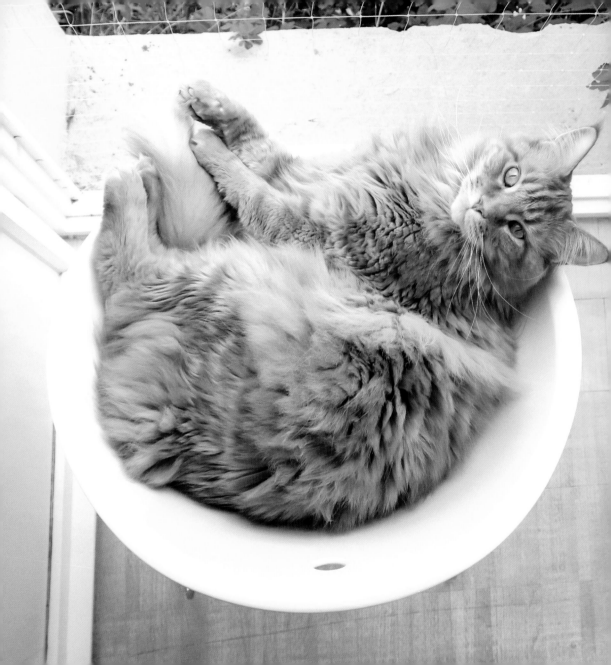

BIRDBATH

CLOSE TALKER

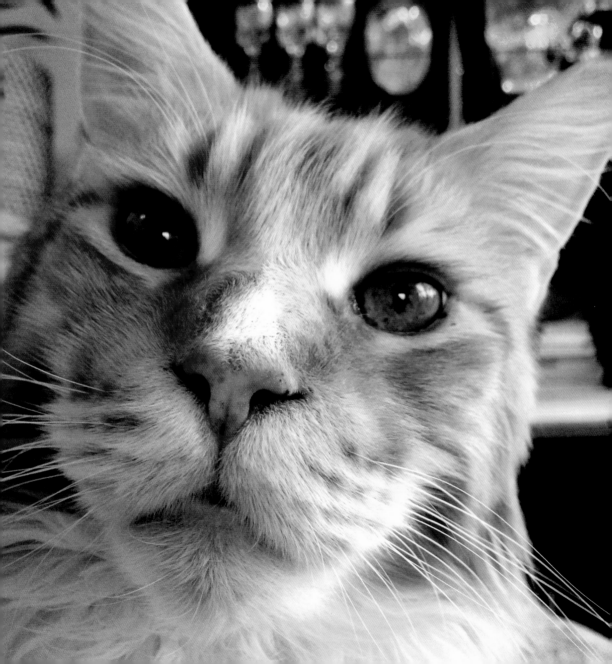

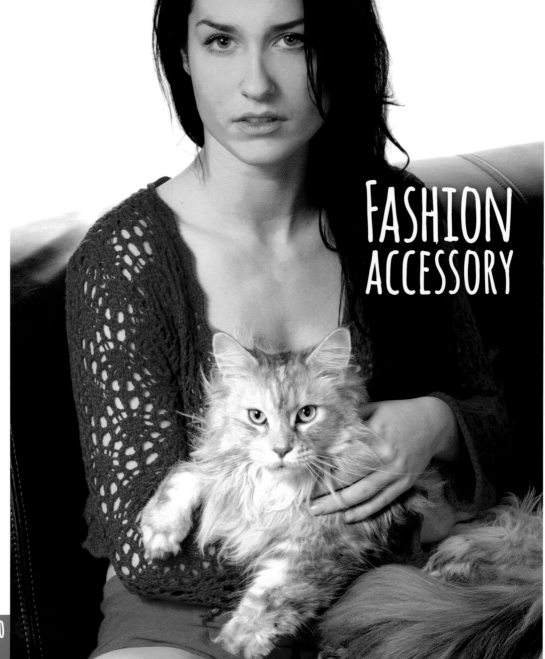

FASHION
ACCESSORY

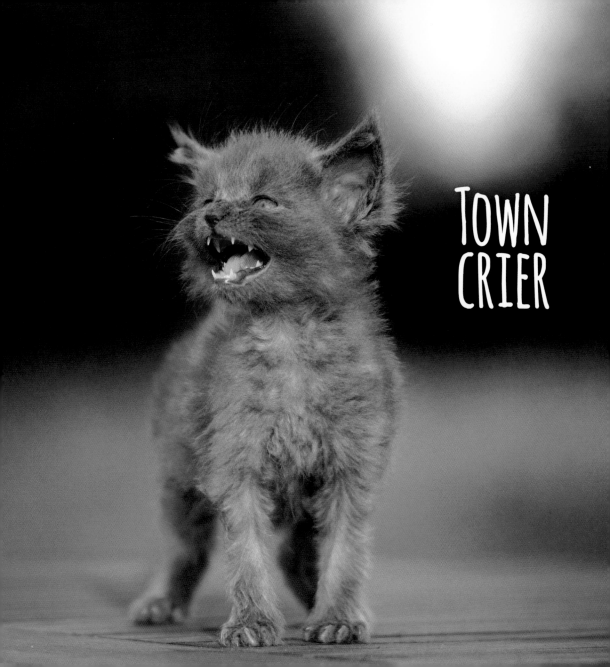

TOWN CRIER

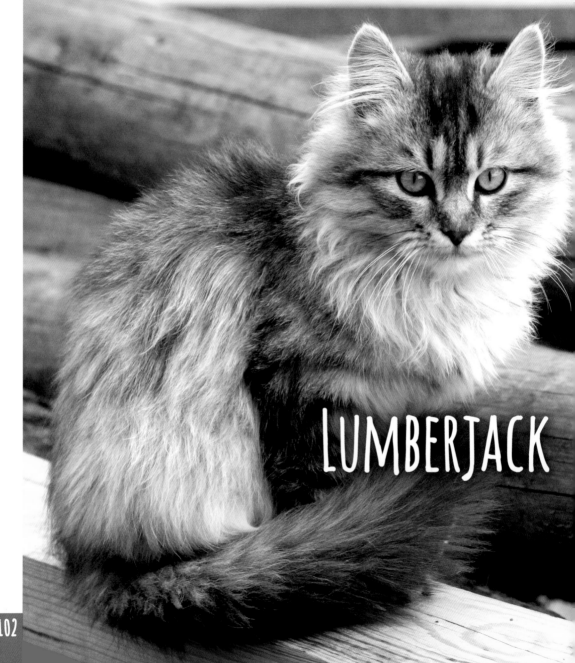

LUMBERJACK

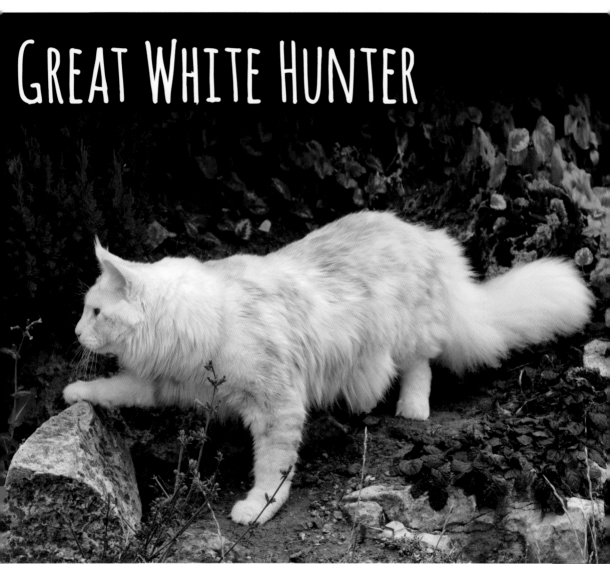

GREAT WHITE HUNTER

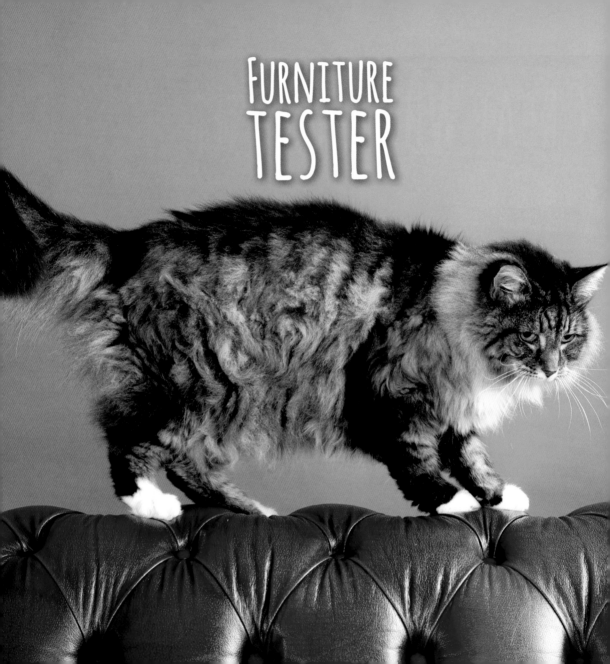

FURNITURE TESTER

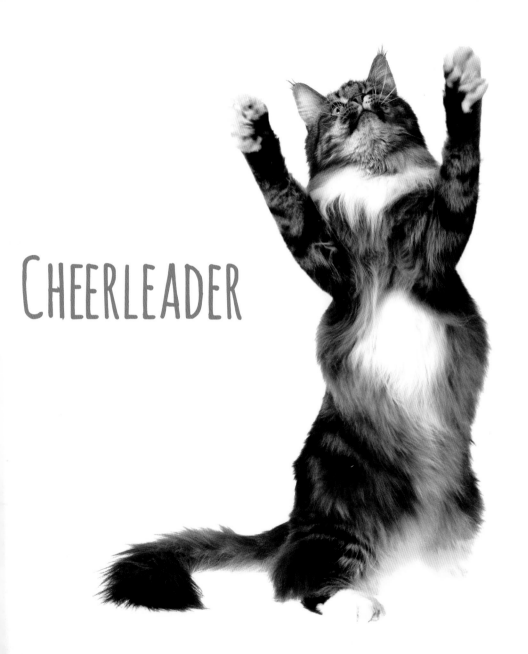

CHEERLEADER

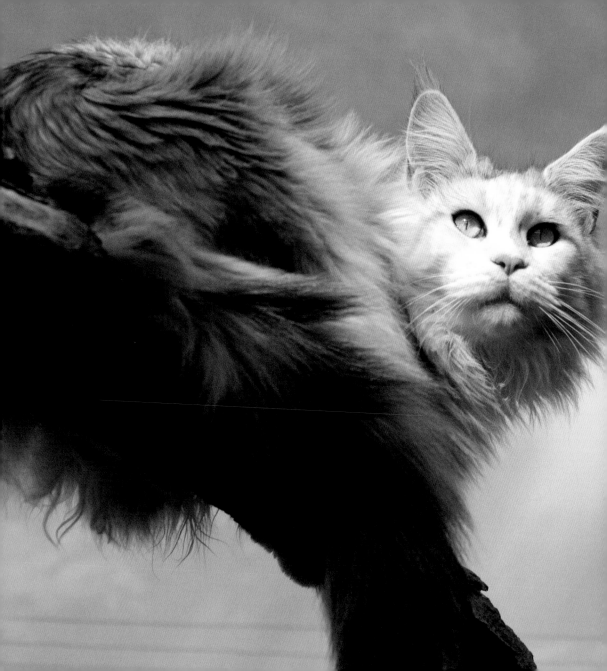

Forest Fire
Lookout

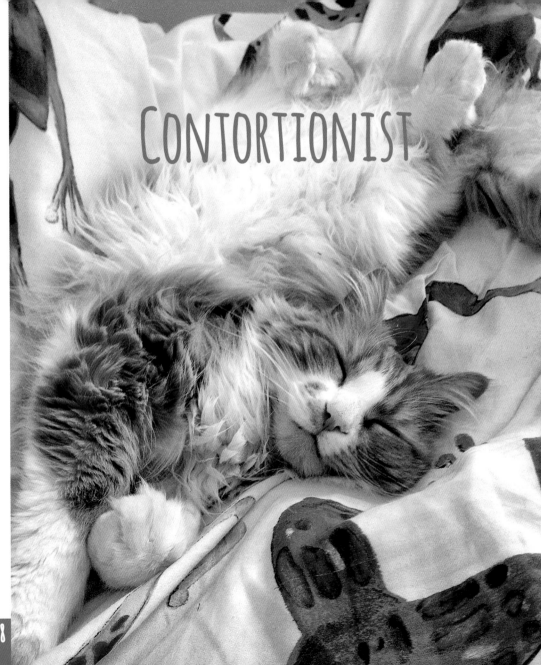

CONTORTIONIST

Deep Thinker

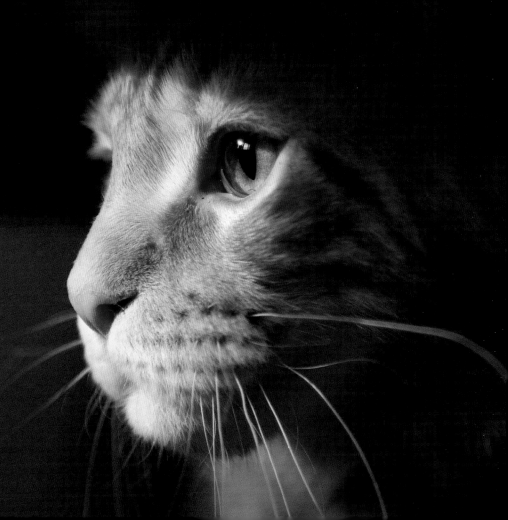

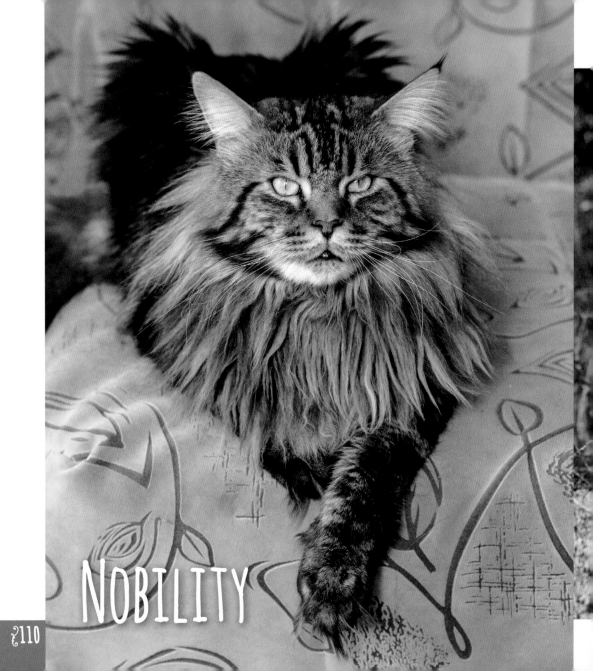

NOBILITY

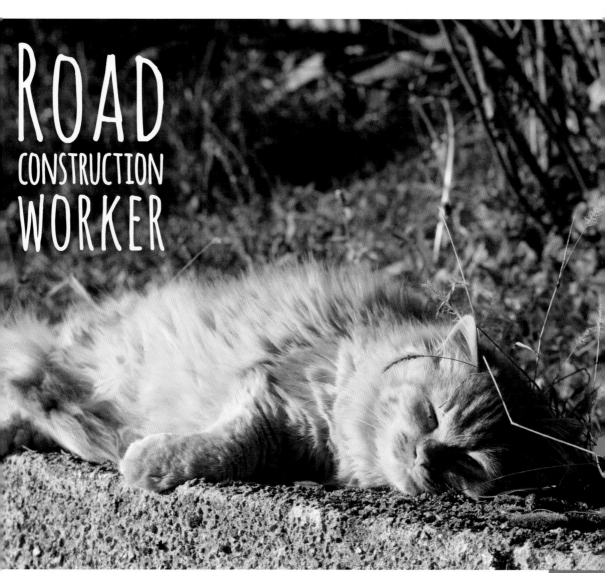

ROAD
CONSTRUCTION
WORKER

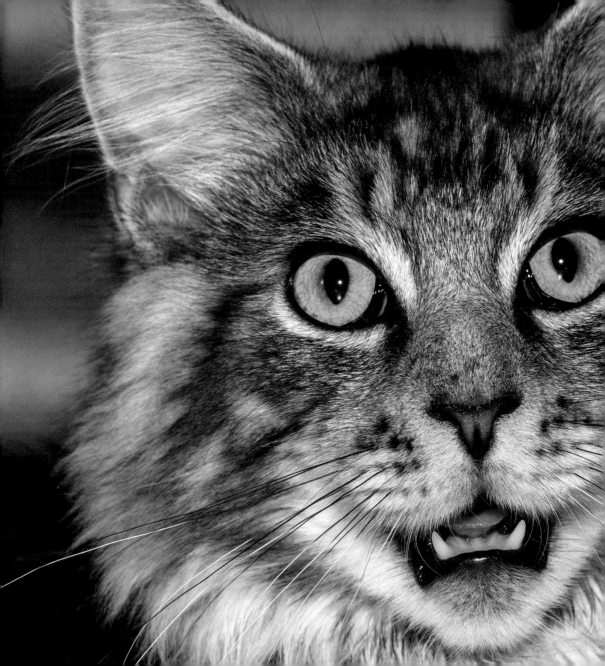

Orator

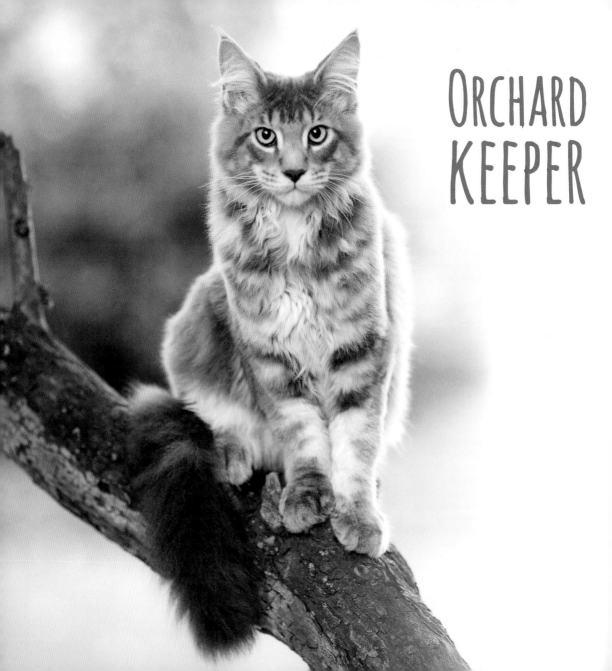

ORCHARD
KEEPER

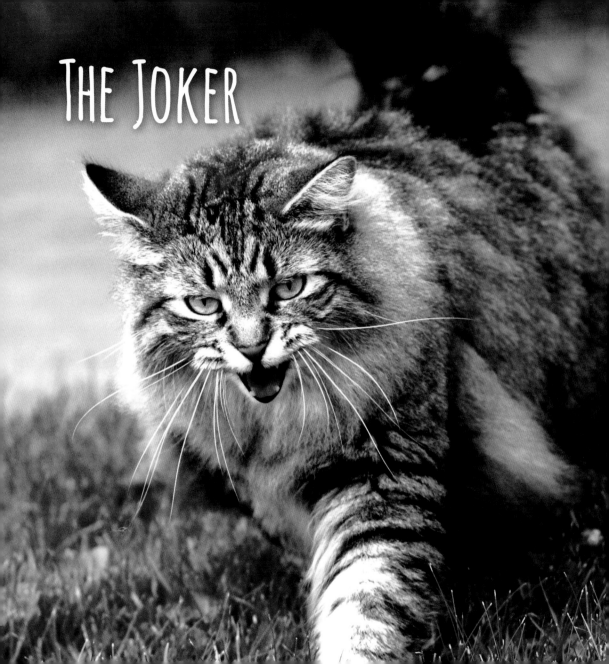

THE JOKER

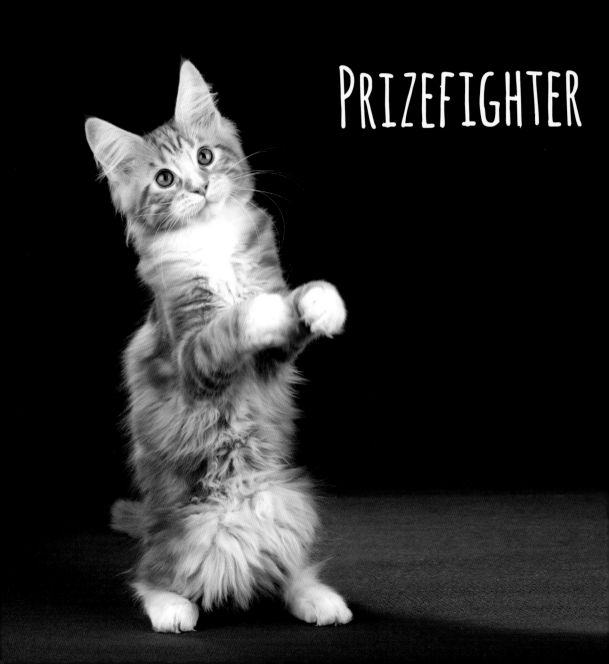

PRIZEFIGHTER

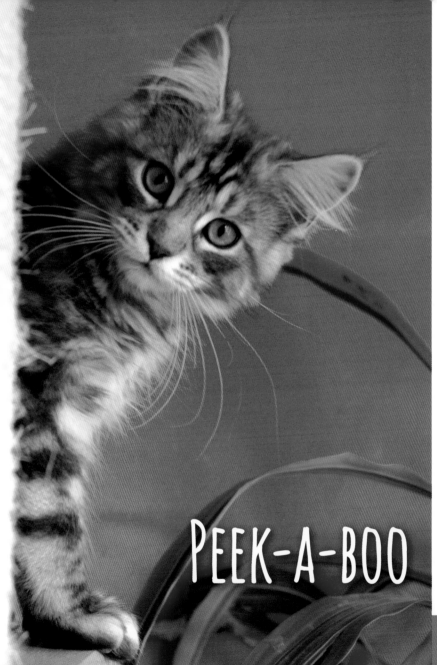

PEEK-A-BOO

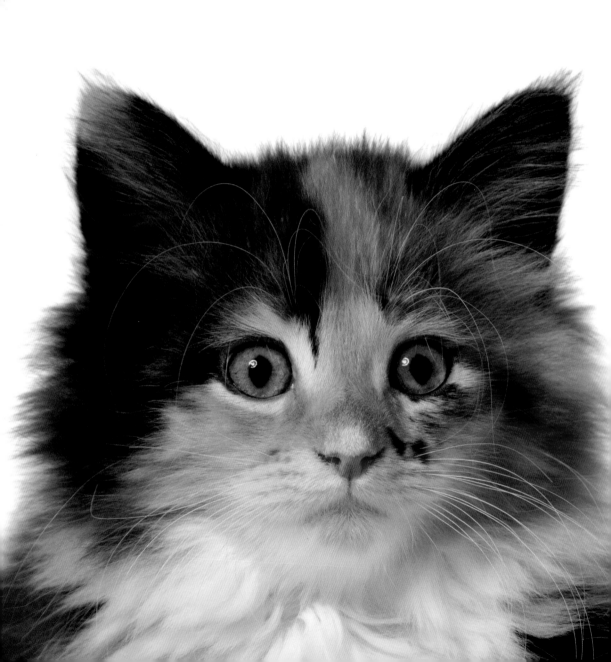

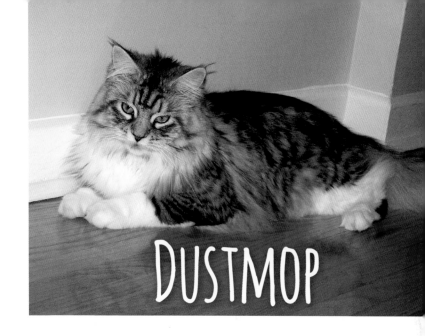

DUSTMOP

SHOCK
AND AWE

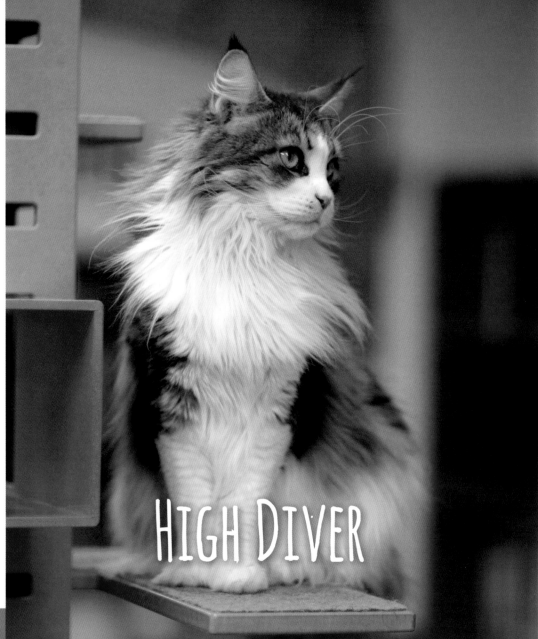

HIGH DIVER

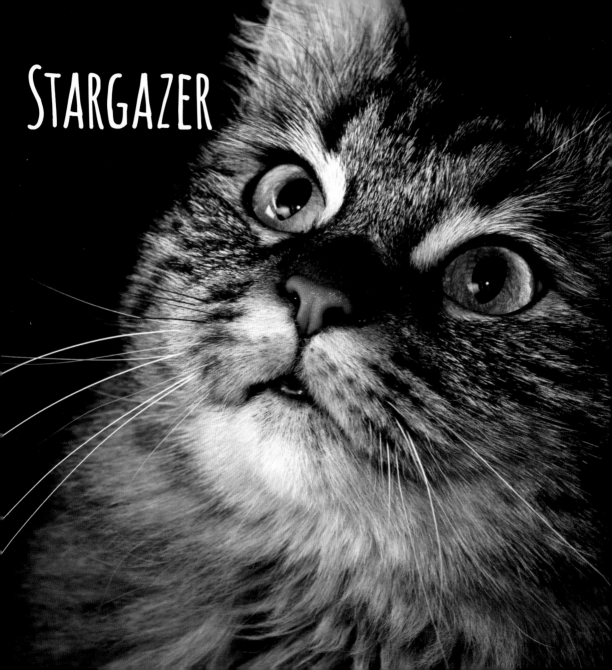

STARGAZER

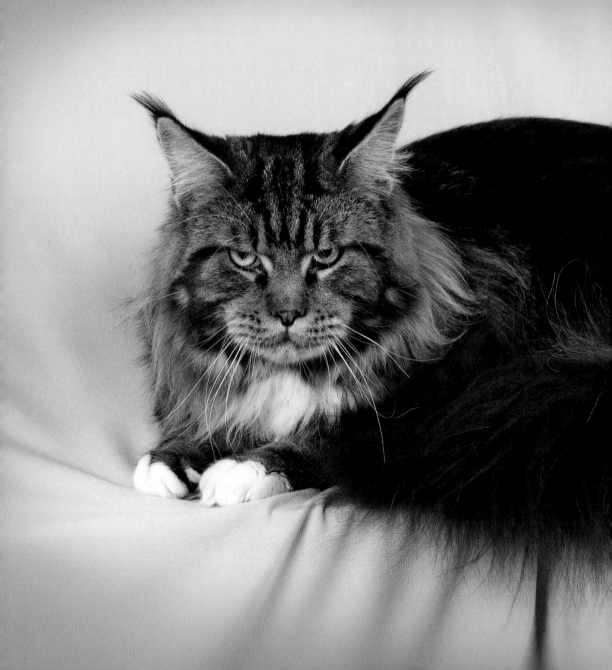

Sourpuss

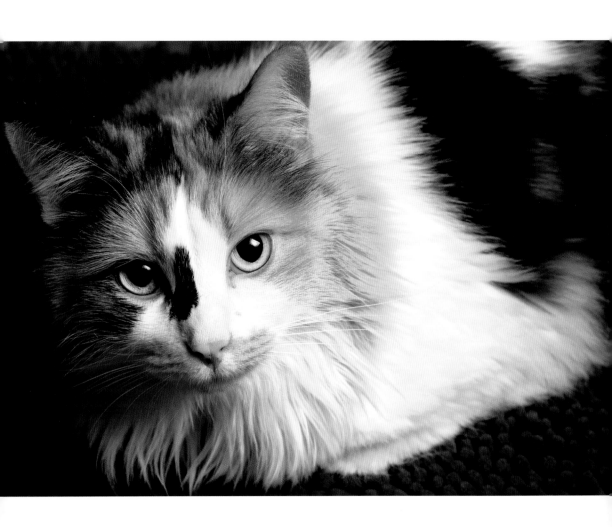

GUINEA PIG

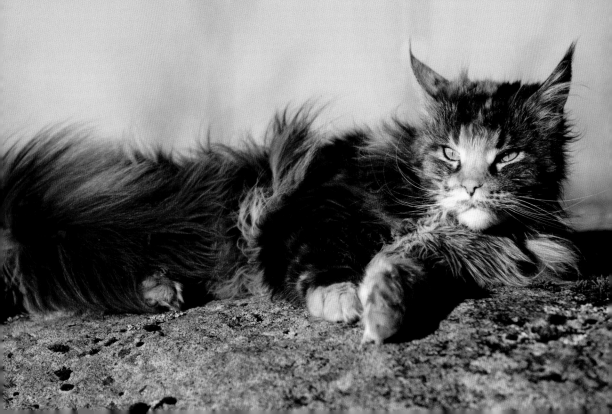

TUMBLEWEED

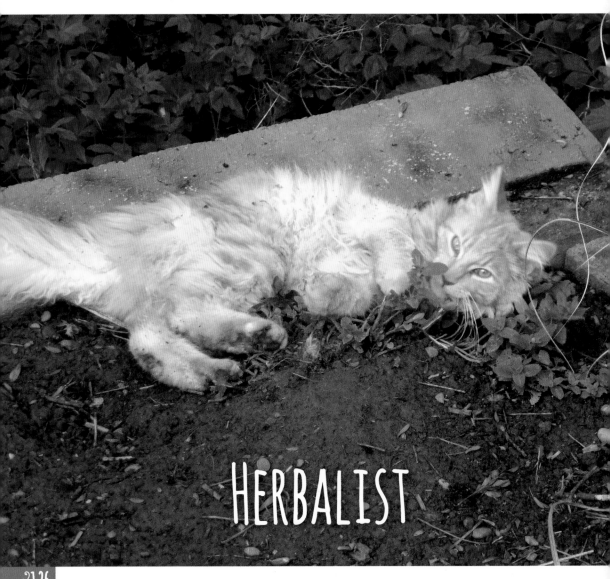

HERBALIST

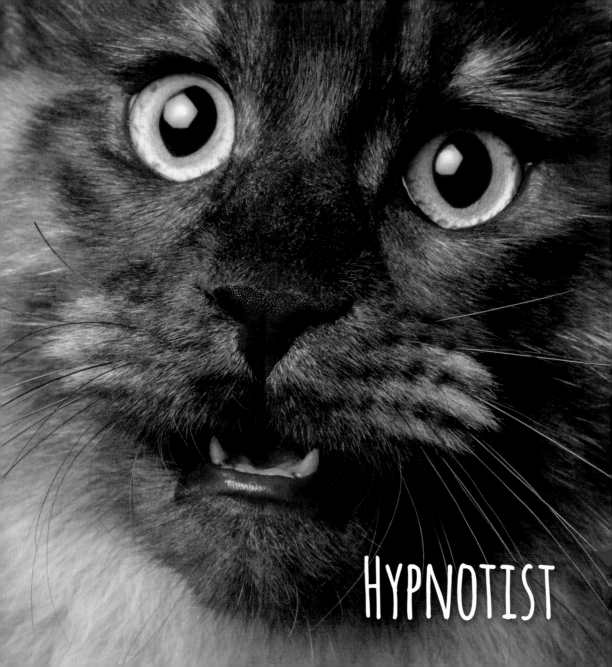

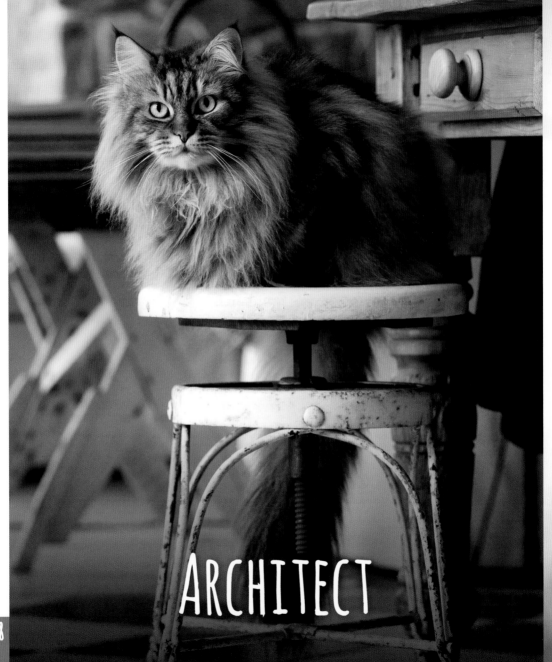

ARCHITECT

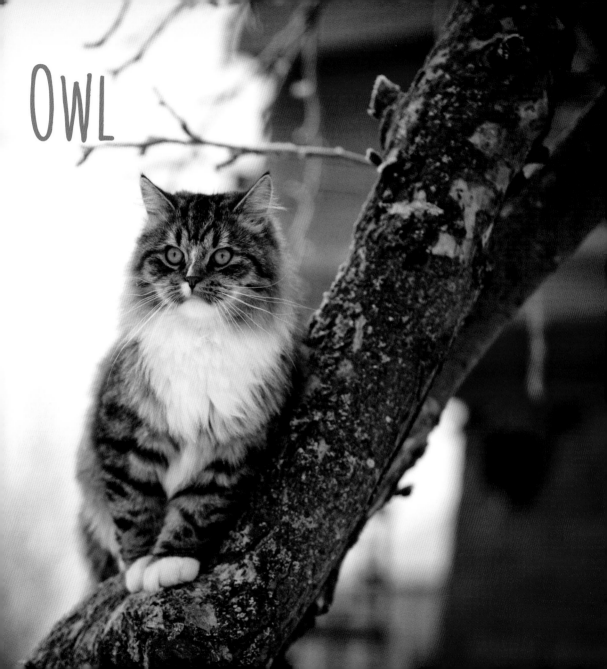

Owl

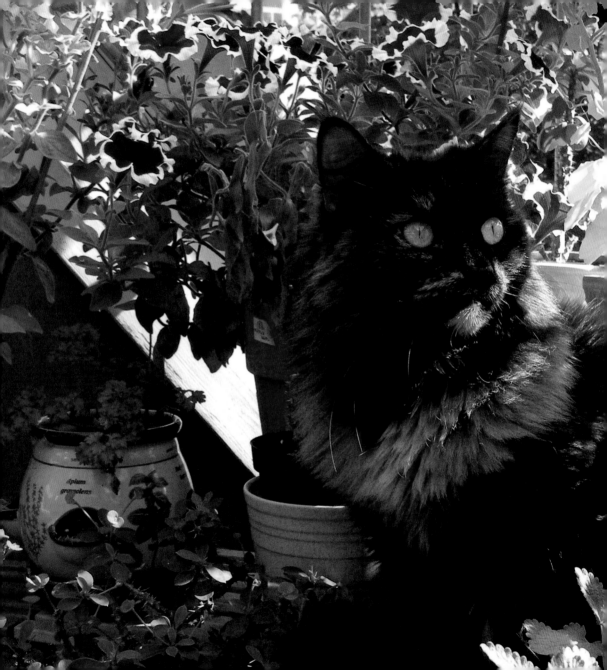

BOTANIST

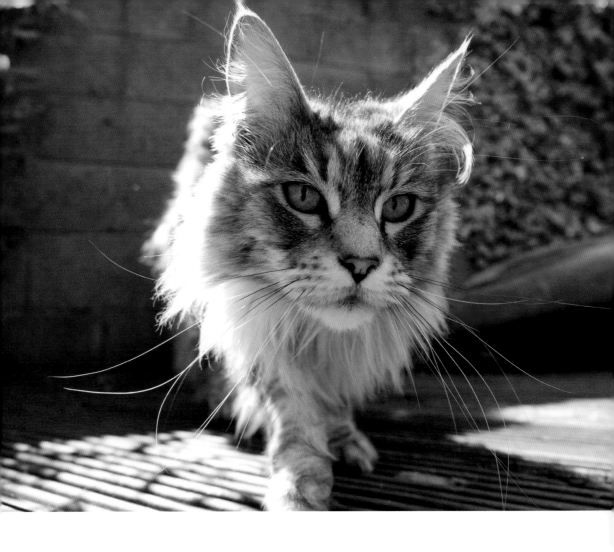

DETECTIVE

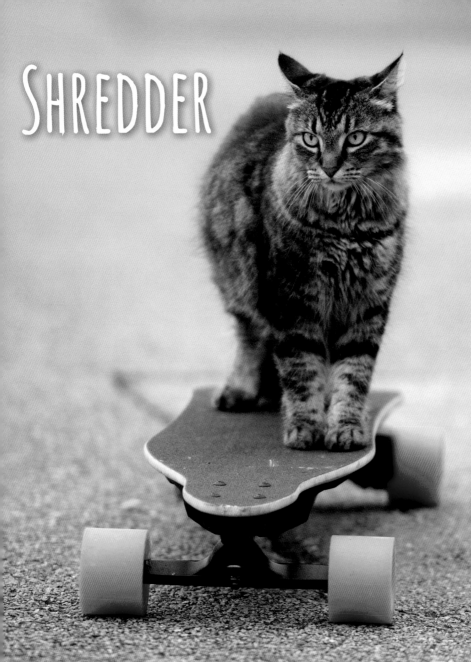

SHREDDER

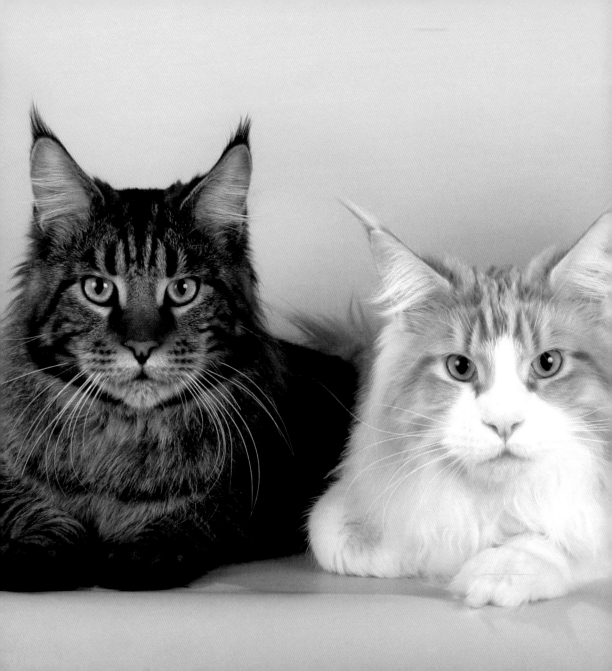

THE
BEE
GEES

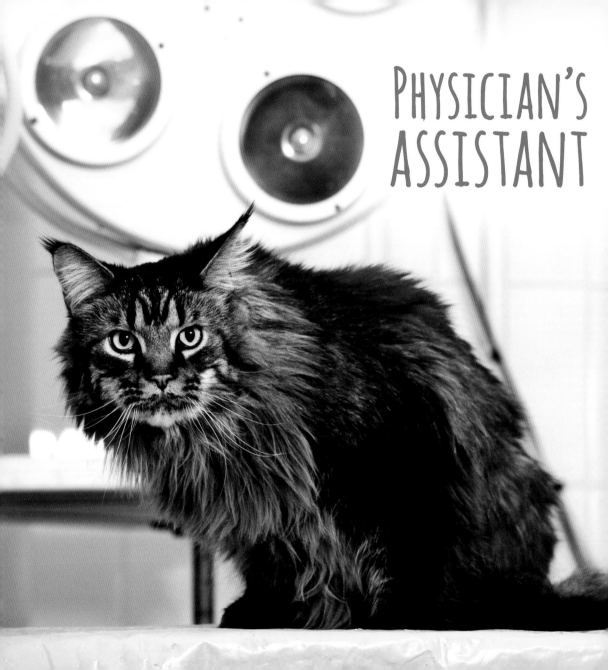

PHYSICIAN'S ASSISTANT